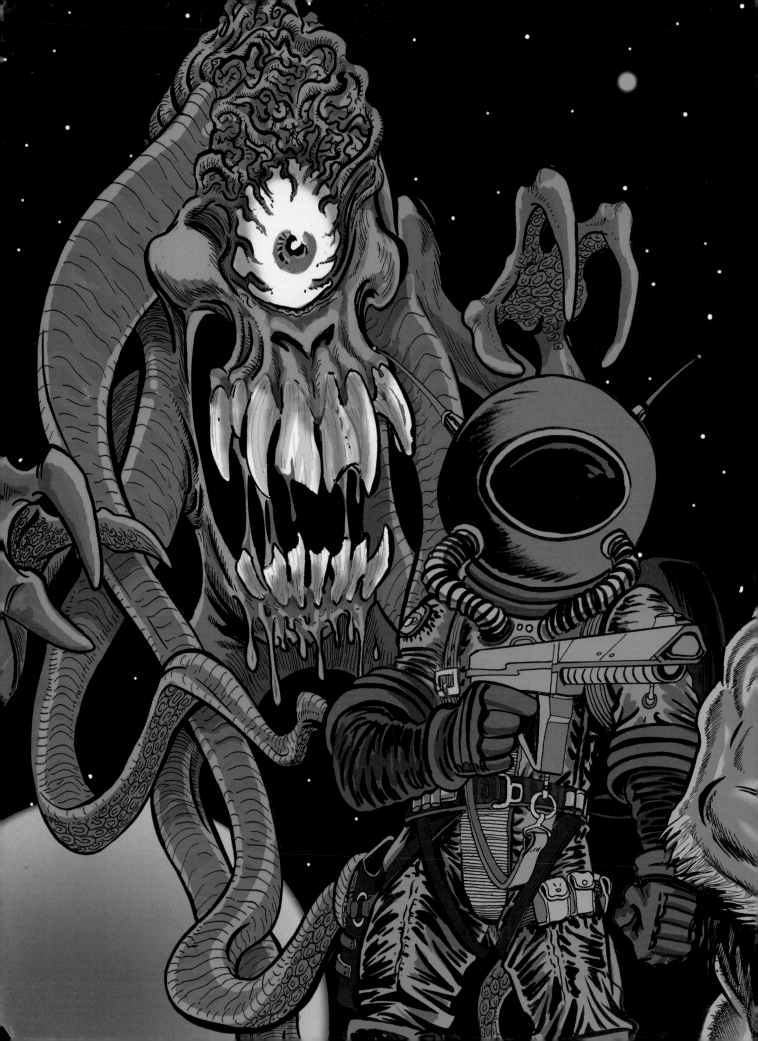

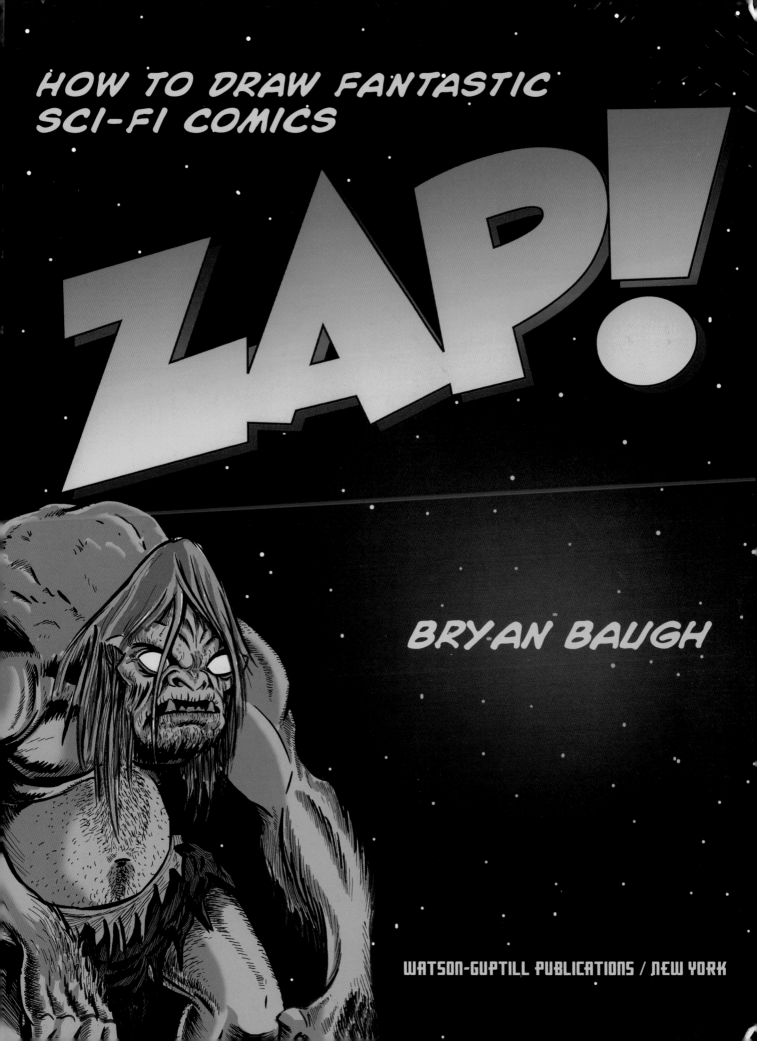

ACKNOWLEDGMENTS

A special word of thanks is due to the generous Al and Cori Williamson, who, in the midst of moving into a new home, still took the time to help make this a better book. Thanks are also due to the following people for their selfless contributions of personal time and helpful information: Monte Wolverton, Bernie Wrightson, Mark Schultz, Bruce Jones, Mark Wheatley, and Ray Cuthbert.

Senior Editor: Candace Raney
Editor: John A. Foster
Design: Jay Anning, Thumb Print
Page Makeup: Eric Mueller, Element Group
Senior Production Manager: Ellen Greene

First published in 2006 by Watson-Guptill Publications,
a division of VNU Business Media, Inc.
770 Broadway, New York, NY 10003

Library of Congress Cataloging-in-Publication Data
Baugh, Bryan.
 Zap! : how to draw fantastic sci-fi comics / Bryan Baugh.
 p. cm.
 Includes index.
 ISBN-13: 978-0-8230-5978-2 (alk. paper)
 ISBN-10: 0-8230-5978-2 (alk. paper)
 1. Science fiction—Illustrations. 2. Cartooning—Technique. I. Title.
NC1764.8.S35B38 2006
741.5'315—dc22 2006010584

Printed in China

First printing, 2006
1 2 3 4 5 6 7 8 9 / 12 11 10 09 08 07 06

This book is for every kid who wishes that a Martian would swoop down from outer space and laser vaporize his school so that he could just stay home and draw.

CONTENTS

ABOUT THE ARTISTS

Jojo Aguilar regularly works as a prop and background designer in the television animation industry. His credits include such shows as *Masters of the Universe, Heavy Gear*, and *Iron Man*, as well as many others. Jojo lives in Santa Monica, California.

Bryan Baugh regularly works as a storyboard artist in the animation industry. He has worked for Disney Animation, Warner Brothers, Sony Television Animation, and others. His credits include such shows as *The Batman, Jackie Chan Adventures, Roughnecks: The Starship Troopers Chronicles, Teenage Mutant Ninja Turtles, Harold and the Purple Crayon, Men In Black, Masters of the Universe*, and *My Friends Tigger and Pooh*. He illustrated the graphic novel *The Expendable One* for Viper Comics and also writes and illustrates his own comic book creation *Wulf and Batsy*. He lives in Thousand Oaks, California, with his lovely wife Monica, and three bloodthirsty killer cats named Lucy, Tiger, and Kayla. You can view more of his work at his Web site, www.cryptlogic.net.

Bill Bronson is a kid at heart. He still watches cartoons from time to time and is a huge fan of chocolate chip cookies. He has a fascination with drawing robots and monsters, watching horror and sci-fi movies, and listening to heavy metal and punk rock. You can view more of his work at his Web site, www.billbronson.com.

David Hartman has worked on just about every facet of the animation industry for almost a decade, from storyboard artist and character designer to Emmy-nominated director. Some of his many credits include MTV's *Spiderman, Roughnecks: The Starship Troopers Chronicles, Astro Boy*, and *Jackie Chan Adventures*. He has illustrated comic books and magazines, including *The Devil's Rejects, The Nocturnals: A Midnight Companion,* and several others. He makes short films about freaks and monsters and was the visual FX supervisor on the cult film *Bubba Ho-Tep*. He is currently developing many projects for Rob Zombie. You can see more of his work at his Web site, www.sideshowmonkey.com.

Steve Miller is an author and artist who has worked in numerous areas of the entertainment industry. His drawings have been used in the production of videos, toys, role-playing games, and video games. Steve's latest book is *Gung Ho! How to Draw Fantastic Military Comics*. He lives in Ohio with his lovely wife and two adorable children. You can see more of his work at his Web site, www.wideopenwest.com/~illustratorx/.

David White is a classically trained artist with interests in all forms of illustration and animation. When not drawing giant robots or making video game models of amazon elves, he likes to hang out at comic conventions chatting with other artists. Dave's freelance career continues to entertain him as he creates art for how-to-draw books, toy designs, trading cards, video games, comic books, and pretty much anything else that is fun and comes with a paycheck! Be sure to check out Dave's Web site, www.mechazone.com

Al Williamson needs no introduction in the world of science fiction art. He is one of the great masters of comic book illustration, having worked for every major comic book publisher. He is best known for his work on the E.C. Comics line in the 1950s, his work on various *Flash Gordon* stories, and his comic adaptations of two classic *Star Wars* films—*Episode 5: The Empire Strikes Back*, and *Episode 6: Return of the Jedi*.

Basil Wolverton is a true example of a cartoonist's cartoonist. As an artist, writer, humorist, family man, preacher, and legendary master of weirdness, Basil is best known for science fiction and humor comics, which he wrote and drew in the 1940s and 1950s. He combined insanity, horror, and comedy with a fierce sense of morality to produce work that had a personality all its own.

Bernie Wrightson is widely recognized as the Master of the Macabre and has illustrated works of Stephen King, Edgar Allen Poe, H.P. Lovecraft, and Mary Wollstonecraft Shelley. His many comic book illustration credits include *Swamp Thing; Creepshow; House of Mystery; House of Secrets; Creepy; Eerie; Twisted Tales;* and *Freakshow*, a hardbound collection of horror comic stories.

INTRODUCTION

There has always been a tendency to categorize any story that takes place in outer space or on another planet as "science fiction." However, this general term is a bit of a misnomer. Not every story featuring spaceships, laser guns, alien life forms, and robots is necessarily science fiction in its purest sense. There's a big difference between true science fiction and what is known as "space opera." They look a lot alike on the surface because they tend to include the same subject matter, but they are completely different in terms of their themes, viewpoints, and overall intent. Perhaps to some it will seem pedantic to quibble over such things. Certainly, the average science fiction fan notices no difference. But if you are reading this, I assume you're not just the average fan. You are here because you have decided to create science fiction comics of your own. That being the case, you would do well to be clear on exactly what it is you are creating. If you want to write and draw your own comics full of heroic space adventurers, evil intergalactic warlords, mechanical automatons, and sexy space queens, you need to understand the difference between the two categories.

▼ **Alien Cliff Battle**
Cleaning up hostile life forms on alien worlds is dangerous work. By Bryan Baugh

The Essential Differences Between Science Fiction and Space Opera

In its purest form, *true* science fiction—or *hard* science fiction, if you prefer—deals with fantastic circumstances that are scientifically plausible based on current scientific beliefs and theories. For example: what life could be like in the future, or on other worlds. Or what might happen if aliens from outer space were to visit Earth. The key to this genre is intellectual speculation. Writers—and readers—of hard science fiction delight in lengthy explanations of a spaceship's engines, a robot's programming, or exactly how the strange atmosphere of an alien planet is able to support life. In fact, one gets the feeling that such explanations are required before the reader— or writer—is willing to believe the fantastic story about to unfold. Science fiction stories also tend to be very plot driven; the primary focus is on the situation at hand. The characters are of secondary importance and are just along for the ride. For this reason, sci-fi is sometimes criticized as being emotionally cold; however, there is no question that many great works have emerged from it. Isaac Asimov (*I, Robot*); James Herbert (the *Dune* series); Larry Niven (*Ringworld*), Arthur C. Clarke (*2001: A Space Odessy*); Robert Heinlein (*Starship Troopers*); and Phillip K. Dick (*Do Androids Dream of Electric Sheep?*) are just a few examples of true science fiction writers. Classic movies such as *2001: A Space Odyssey* by Stanley Kubrick; *Forbidden Planet* by Fred M. Wilcox; *The Day the Earth Stood Still* by Robert Wise; *Close Encounters of the Third Kind* by Steven Spielberg; and the television show *Star Trek* by Gene Rodenberry are all examples of true science fiction.

Space opera, on the other hand, is more of a character-driven genre. The characters guide the plot, not the other way around. Writers and readers of space opera aren't interested in discussing the mechanics that allow a spaceship to fly across the galaxy: they only care about what happens to the person in the pilot's seat. Nor are they concerned about how a robot's logic circuits work: they just want to know what the robot thinks and maybe feels. In space opera no time is wasted explaining technological or theoretical elements, and scientific plausibility is no sticking point. Space operas are all about the thrill of adventure and the lives and relationships of the characters involved. This basic difference in intent is the primary reason why space operas cannot be classified as true science fiction. Rather, a space opera is like a fantasy adventure in science fiction disguise. *Flash Gordon* (both the classic comics by Alex Raymond as well as the various film adaptations) is a defining example of space opera. So is Philip Francis Nowlan and Richard Calkins' *Buck Rogers* and George Lucas' *Star Wars* saga. By the same token, Ridley Scott's film *Alien* could be called a horror story in science fiction disguise.

Perhaps you are wondering why I have not yet mentioned Ray Bradbury, who, since the 1950s, has been repeatedly referred to as the greatest science fiction storyteller of all time. I save Bradbury for last simply because he cannot be strictly categorized. Bradbury is one of those rare writers whose work successfully blurs the line between pure science fiction and space opera, offering tales of the highest emotional content and thrill that still remain scientifically plausible to satisfy even the toughest sci-fi critic. If you don't believe me, read his classic book *The Martian Chronicles*. Trust me, you won't regret it! And, if you are planning to create some sci-fi or space opera of your own, you will learn a lot from it.

The point here is not to say that either science fiction or space opera is necessarily better than the other. I am merely pointing out the differences so that you will be able to better define your own work. Although it may seem that this discussion has more to do with the writing process of sci-fi comics, it does not. The difference will affect the way in which you illustrate your material. For example, should you decide your story will be pure science fiction, you will certainly want to draw futuristic technology that appears as if it would actually function. Some artists eagerly delve into this approach and research gears, engine parts, hydraulics, and other gizmos that make real-life machines work and then apply the contemporary parts to the high-tech space vehicles and robots they draw. Other artists study biology so that they can draw believable alien life forms.

On the other hand, if you're drawing a space opera, such intricacies are less important than just capturing the right feeling. An evil robot shaped like an octopus probably doesn't make a lot of logistical sense. Most readers of "hard" science fiction, who generally require some reasonable explanation for the fantastic elements in their entertainment, would never accept it. They would demand to know why any scientist would ever build it that way. What purpose does it serve? But in a space opera, where you aren't required to explain yourself at every turn, this sort of thing works fine. Why? Because it triggers the right emotional response. You needed the evil robot in your story to be scary, and a robot shaped like an octopus, with eight mechanical tentacles waving around trying to grab the hero, is pretty darn scary. And that's all that matters. Simply put, science fiction is about "thinking"; space opera is about "feeling."

▲ **Space Harpy**
Claws and bat wings give this alien female a somewhat sinister appearance. By Jojo Aguilar

▶ **Octobot**
Robots can come in all shapes, as this deadly Octobot demonstrates. By Bill Bronson

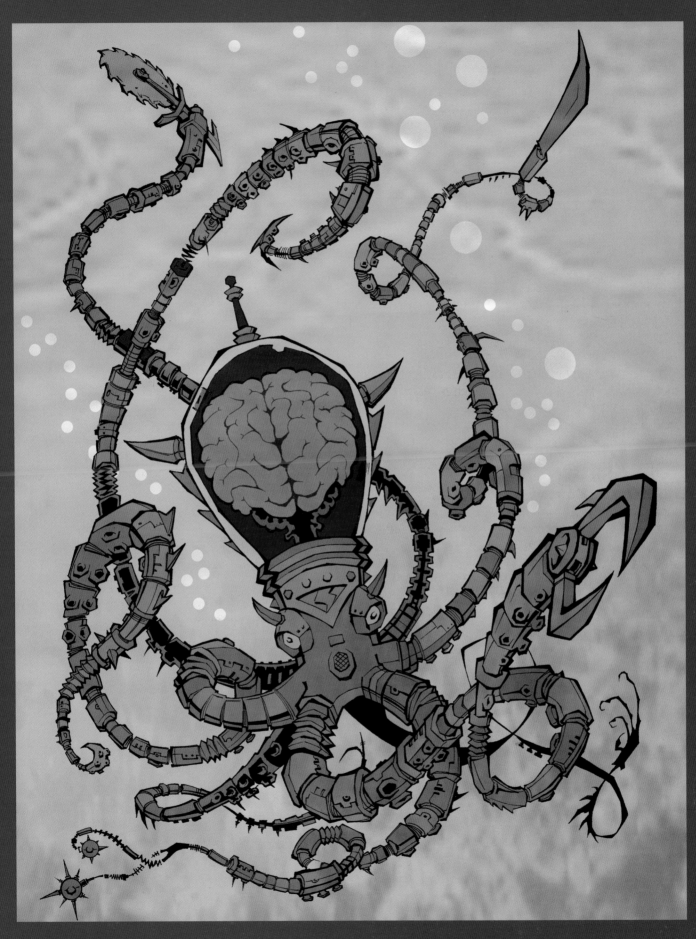

PART ONE
A BRIEF HISTORY OF SCI-FI COMICS

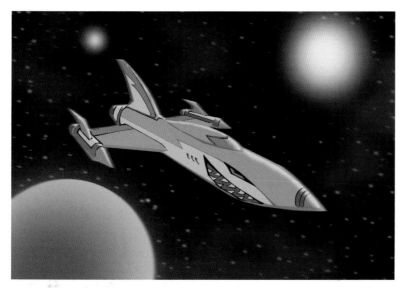

THE BRIGHT FUTURE AHEAD

Science fiction first came into prominence in the late 1920s in pulp magazines such as *Amazing Stories* (1926) and in comic strips such as *Buck Rogers* (1929). During this time, sci-fi art reflected society's optimistic view of the future. The depiction of futuristic technology was always shiny and flawless. Spaceships were sleek rockets with elegantly curved fins. Astronauts wore flashy silver jumpsuits, and robots often had the decorative look of walking jukeboxes. Everything gleamed as if it had just been waxed and polished a moment earlier. This dreamy vision took comfort in the idea that the golden age of humanity still lay ahead and that the human race's ability to travel among the stars would be its apex. Technology was to carry the human race to its greatest era, and when that time came, the only ugly things to be found would be scary monsters on alien planets, which humans would swiftly eliminate in order to populate the universe. Perhaps no single work encapsulated this fantasy more perfectly than a little space-opera comic strip that premiered in 1934 entitled *Flash Gordon*.

◄ **Bronson Rocket**
An especially sleek fighter craft for zipping through space and battling alien invaders. By Bill Bronson

▼ **TreadBot**
For robots stationed on planets with rough, treacherous surfaces, treads are better than legs. By Bill Bronson

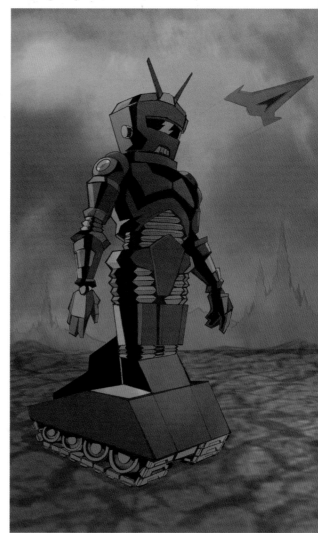

ALEX RAYMOND'S *FLASH GORDON*

Alex Raymond's comic strip *Flash Gordon* is, in many ways, the primer for all sci-fi comics. It is space opera stripped down to its purest form. If you have any interest whatsoever in drawing science fiction comic art, it would be extremely beneficial to spend some time studying this material, since it has been the foundation for so much sci-fi comic art for the past seventy years. It may be tricky to find copies of these old comics, but collections have been reprinted in book form.

The premise of *Flash Gordon* is both simple and effective. Professor Zarkov, a famous scientist and inventor, discovers that Earth is about to be destroyed by the planet Mongo. The professor, along with the courageous Flash Gordon and his lovely companion Dale Arden, travels to Mongo in a rocket ship and tries to prevent the catastrophe. Upon arriving, the brave trio discovers that the planet is ruled by the evil emperor Ming, the mastermind behind the plot to destroy Earth. Through good old-fashioned swashbuckling heroics and futuristic science, Professor Zarkov, Flash, and Dale manage to save the day. However, they remain on planet Mongo and swear to help Mongo's oppressed citizens to fight against Ming's evil tyranny. Naturally, this premise led to years of countless adventures.

The Strangler
By Alex Raymond.
Copyright © King
Features Syndicate

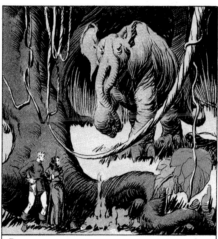

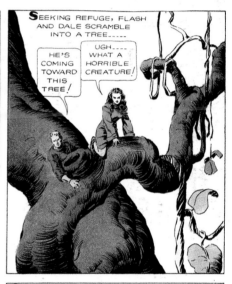

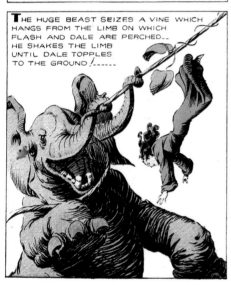

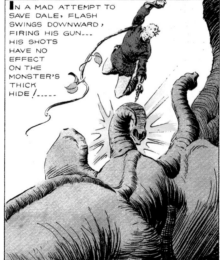

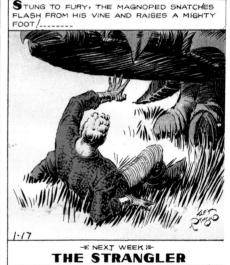

To be brutally honest, Alex Raymond's creation was a product of a simpler time, intended for a young audience. For modern readers, the original Flash Gordon stories may seem overly simplistic, overly romantic, naive, or just downright silly. Perhaps this indicates a jaded modern viewpoint that takes imaginative storytelling for granted, or perhaps it really does indicate weaknesses with the quality of Raymond's writing. If this were a book about how to write science fiction comics, perhaps we would spend some more time hashing it out. But we're concerned with artwork, and as far as that goes, Raymond's *Flash Gordon* is absolutely timeless. It remains an extraordinary vision, every bit as powerful and vibrant today as it was when first published in the 1930s.

Raymond's handling of human anatomy is nothing short of masterful. Artists can learn a lot from his handsome, rugged heroes; stunning, glamorous women; and crooked villains—not to mention the life, movement, and individuality he gives each character in every scene. His settings, from gloriously spired palaces to murky, vine-dangling jungles, never fail to evoke the appropriate mood and atmosphere. But most enjoyable are Raymond's fantasy creations, such as sleekly finned rocket ships and bizarre kingdoms of alien life forms. These are elements of total imagination, yet Raymond draws them with the same seriousness and conviction that he gives to his classically rendered human forms. All of this is contained in a world of rushing, swirling lines and brushstrokes that direct the viewer's eye through each drawing and simultaneously add luxurious shadows and textures to each sequence.

Some critics argue that as Raymond continued drawing *Flash Gordon* comics into the 1940s, he got better at drawing people but lightened up considerably in the intricate detail and line work that made his work in the 1930s so powerful. Raymond fans go back and forth on this, but it's really just a lot of quibbling. Personally, I think *Flash Gordon* looks its very best in the mid to late 1930s, and would recommend that era of material first and foremost to any new inductee. But it's all great, and, simplified or not, his 1940s work—particularly his people—offers a lot to modern artists.

If great actors learn by studying Shakespeare, and great musicians learn by studying Mozart, and great writers learn by studying Hemingway, then great science fiction artists learn by studying Raymond. It's as simple as that.

Martian Warrior
A classic vision of a Martian warrior. By Bernie Wrightson

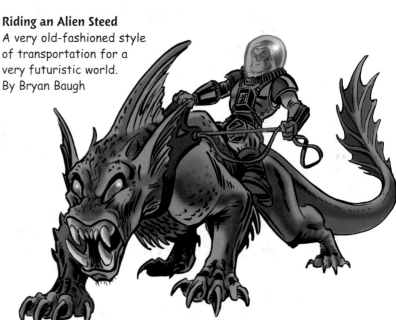

Riding an Alien Steed
A very old-fashioned style of transportation for a very futuristic world. By Bryan Baugh

Martian War Machine
A frightening display of military strength from an alien
world attempting to conquer Earth. By Bill Bronson

The Movie Serial Version of *Flash Gordon*

In 1936, amid the growing popularity of the *Flash Gordon* comic strips, Universal Studios quickly produced a big-screen adaptation. Rather than adapting the continuing adventures of Flash Gordon into a single two-hour motion picture, Universal chose to make a thirteen-chapter movie serial. The fifteen- to twenty-minute-long chapters were released once a week and screened at theaters before the feature movie. In an era before television, the serial format hooked kids and kept them coming back to the movie theater every single weekend. If they missed the show on Saturday—*Yikes!*—they would miss a new chapter of Flash Gordon's adventures.

The first *Flash Gordon* serial, also known as "Space Soldiers," was hugely successful for its time, becoming one of the biggest moneymakers of the 1930s. The story was faithful to Alex Raymond's original plot, and the cast was perfectly chosen. Buster Crabbe, a former Olympic athlete, was ideal in the role of Flash, due to his genuinely clean, all-American nice-guy appeal and his uncanny resemblance to Raymond's Flash character. Charles Middleton, a long-time movie villain, was a sneeringly sinister Ming, and Frank Shannon was fitting as the refined Professor Zarkov. And finally, Jean Rogers—although blonde, unlike Raymond's brunette heroine—made for a believably innocent yet achingly sexy Dale Arden.

Confrontation
A heroic space pirate and his robot companion face a typical challenge.
By Bryan Baugh

The thirteen-chapter serial gave kids of the 1930s something they had never experienced before: a roller coaster of nonstop action sequences that took place in a surrealistic wonderland of rocky landscapes with art deco rocket ships, sword-fighting spacemen, exotic women, death rays, lethal traps, lion men, hawk men, shark men, ape men, alien tigers, alien gorillas, and one very crazy-looking, lobster-clawed cave dragon.

By today's standards, the original *Flash Gordon* serial looks and feels sadly dated. This is the price we pay for advancement, especially where movies are concerned. As filmmaking techniques improve, the old entertainments that once seemed so original and imaginative lose a lot of their power. Now, in an age of digital special effects technology, the original *Flash Gordon* movie serial appears laughably primitive. Its rocket ships, floating cities, and distant planets hanging in the sky are obviously models suspended on wires. The aliens are obviously musclemen wearing funky makeup or klunky monster suits. The costumes and sets are borrowed items from the prop departments of other Universal productions. (Notice all those slightly modified Roman soldier outfits, not to mention bits of statuary from *The Mummy* as well as the lab equipment and the great stone staircase from *Bride of Frankenstein*.)

Nevertheless, this serial can still be a lot of fun to watch, if one is willing to drop one's twenty-first-century pretensions and appreciate it from the perspective of the period in which it was made. In other words, instead of criticizing its shortcomings, viewers would do well to take into consideration the film's accomplishments *in spite of* the technological limitations of its era.

The *Flash Gordon* serial also deserves respect for its place in history, because it inspired so many great fantasy artists and filmmakers who were young during the twenty-year period when it was repeatedly shown in theaters, from the 1930s to the 1950s. For example, without *Flash Gordon* there might never have been a *Star Wars*.

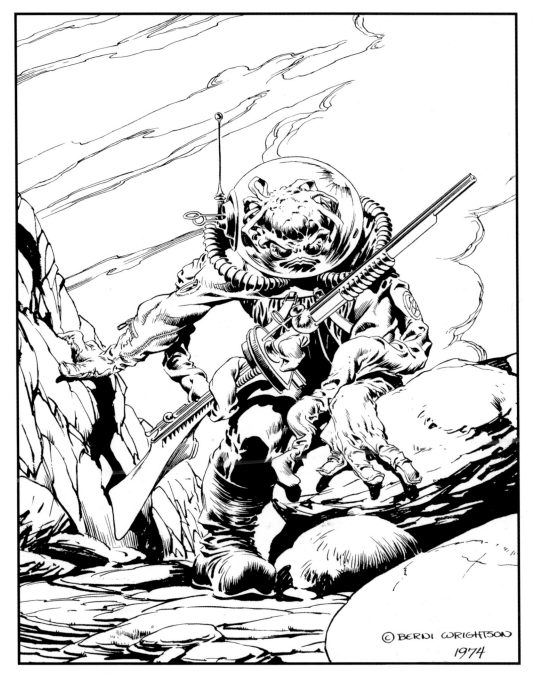

Space Invader
A particularly ugly alien
slithers toward us.
By Bernie Wrightson

George Lucas has been very vocal about the fact that his epic film series was heavily influenced by *Flash Gordon*. Interestingly, when you compare *Flash Gordon* and *Star Wars*, the story and visual inspirations are quite obvious. Consider the following similarities: the perfect blend of fairy tale romanticism with science fiction motifs; the telling of each story in continuing chapters, with cliffhanger action sequences building the excitement at every step; the opening scroll of text that sets the scene at the beginning of each chapter; an alien world ruled by an evil galactic emperor; a fair-haired hero who wields a medieval sword in a futuristic environment; trap doors and arenas of death where the heroes are forced to battle monstrous creatures for the villain's entertainment; the villain's lecherous habit of kidnapping the heroine and refitting her in a skimpy harem-girl costume; spaceship battles; floating cities in the sky; and a small, rebellious group of heroes battling a tyrannical monarchy. All of these elements have become classic motifs of space opera and fantasy.

THE GUY, THE GIRL, AND THE GOON

During the 1940s and 1950s, a clever, if gratuitous, manner of illustrating comic book covers became popular that was derived from a tried-and-true marketing gimmick used in movie posters. This particular trend got kick-started by a little publisher named Fiction House. Recognizing that their target audience was young and male, Fiction House made it their main comic book selling strategy to adorn their comic book covers with images of beautiful women. Sometimes the women were the action-adventure heroines of the story; other times they were merely damsels in distress. Either way, whatever genre Fiction House tackled, they always found an excuse to feature a scantily clad female on the cover. Their sci-fi title was called *Planet Comics*, and the Fiction House rule was that the cover of every issue must contain three crucial ingredients: a heroic male, a lovely female, and some sort of terrible villain. This formula came to be called "The guy, the girl, and the goon." Although not terribly original, it was extremely successful. It could be repeated without feeling repetitive, because it could be executed countless different ways. Sometimes "the goon" was an alien monster, an evil human, or a killer robot. Often "the girl" was being victimized by "the goon," with "the guy" rushing to her rescue. Occasionally, it was the guy's turn to be the victim. He'd be shown obviously losing a desperate fight against the goon, with his only hope being a heroic blonde flying overhead with the help of a rocket pack, carefully aiming her weapon at the enemy. "The guy, the girl, and the goon" formula ensured sales because it promised heroic action, sex appeal, and scary violence, a formula of which Fiction House's young male readership would never tire.

Impending Danger
Being the first Earthlings to arrive on an alien planet does not guarantee you a warm welcome.
By Bryan Baugh

Alien Invasion
A lovely damsel in the clutches of a hideous alien invader. This illustration was intentionally patterned after the style of posters used for science fiction films of the 1950s. By Bernie Wrightson

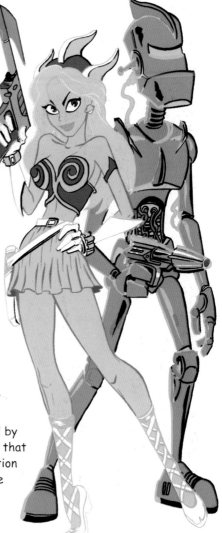

◄ **Crater Creep**
Be careful when exploring moons. You never know what might pop out of a shadowy crater. By Bryan Baugh

▶ **Rocket Rachael and Rodney the Robot**
Intergalactic space adventurers come in all different shapes. This illustration was inspired by the style of characters that appeared in science fiction adventure comics of the 1940s. By Bryan Baugh

BASIL WOLVERTON'S *SPACEHAWK*

No sci-fi comic book artist achieved better results with pure, unadulterated weirdness and a good sense of humor than Basil Wolverton. He began his career in the late 1930s with a comic entitled *Spacehawk*, which told, quite simply, the continuing adventures of a mysterious space warrior who traveled from planet to planet to defend innocent people from alien monsters. Unlike previous sci-fi heroes such as Flash Gordon and Buck Rogers, Spacehawk was not a clean-cut, smiling, good-natured hero. Rather, he was introduced as a grim figure whose only readable expression was the eternal frown of a threatening helmet with narrow eye-slits. Spacehawk was a cold and calculating dispenser of justice who would whip out his laser gun and simply blast evil aliens to death without hesitation.

Another famous Wolverton character was Lena the Hyena, the winning cartoon illustration in the notorious Ugliest Woman Alive contest held by the legendary cartoonist Al Capp in 1946. This single character made Wolverton famous for his laboriously detailed portrait-style cartoons of hideously ugly faces. Some of these cartoons are funny looking, some are vaguely disturbing, and some are just downright scary. In the 1950s Wolverton illustrated short stories for various sci-fi horror anthology comics, and later created cartoons for *MAD* magazine. A devoutly religious man, in the final years of his life Wolverton set out to create an illustrated version of the Holy Bible, which he intended to be his magnum opus. What made Basil Wolverton legendary was not only his vast imagination but also his bizarre drawing style, which was well suited to the ultraweird, darkly humorous sci-fi stories he chose to illustrate. Everything in Wolverton's imaginary world, from monsters and mutated people to landscapes, appears to come from another planet. His art style has been affectionately described as "the spaghetti and meatballs approach." And yet, despite his fame, Wolverton was a refreshingly down-to-earth man. I recently had the pleasure of asking Basil Wolverton's son, Monte Wolverton, a few questions about his father's life and work.

▶ **Spacehawk and the Creeping Death from Neptune** Spacehawk ensures justice and defeats Martian space pirates. By Basil Wolverton

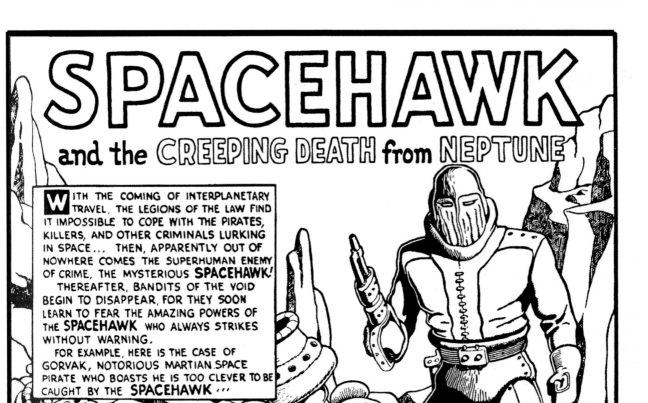

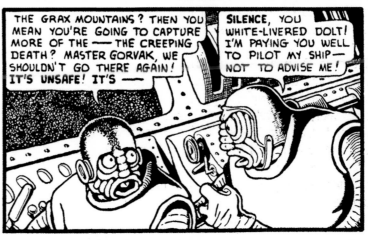

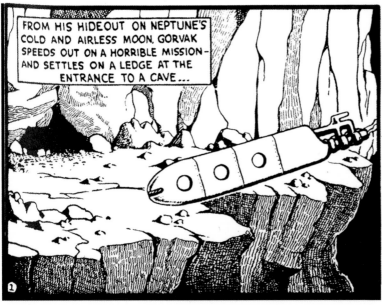

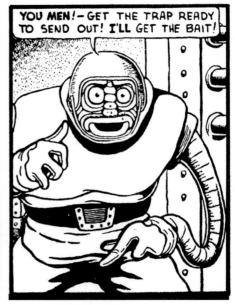

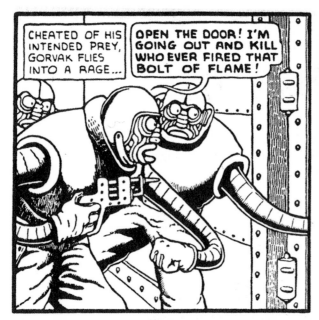

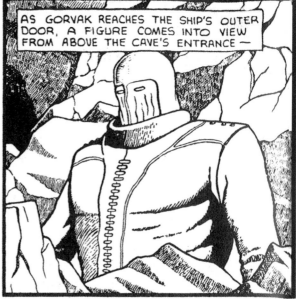

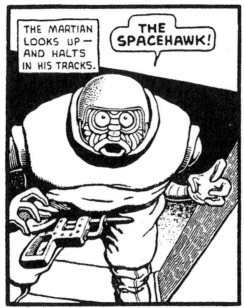

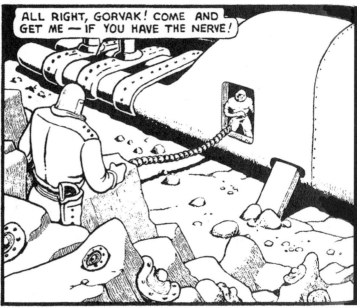

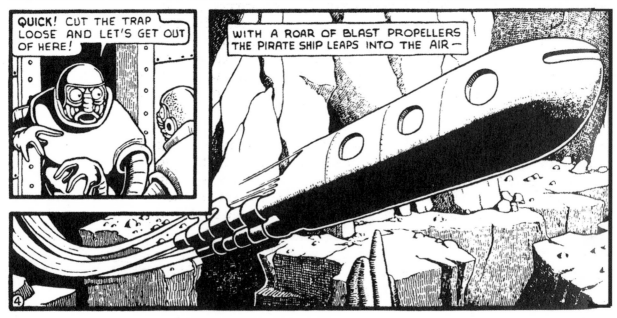

AN INTERVIEW WITH
MONTE WOLVERTON

First off, I have to ask, what was it like growing up as the son of Basil Wolverton? A man who makes a living drawing monsters and aliens must have made for an interesting father figure. Any anecdotes you'd like to share?

I remember being aware that my friends' dads worked in offices or factories, but my dad worked at home at a little drawing board, pecking away at really odd artwork. Vancouver, Washington, was much smaller than it is now, and locals were aware of my dad—not so much from his comic work but from the publicity he had received in the late nineteen forties from Lena the Hyena. So my teachers were aware of my dad, and I had a certain reputation to live up to—or down to—as a cartoonist's kid. He was happy to draw stuff for my friends who asked. His favorite thing was a cow with a hoof stepping on one of her own very full udders. I can't remember how many of my friends took one of these home, but I seem to remember someone's parents thinking it was in poor taste.

I never had to battle my parents to let me read comic books. My dad would have been worried had I not been reading them. My dad was not really a bizarre person. All his weirdness went onto the drawing board. At home he was concerned about his yard, his vegetable garden, fishing and camping trips, family, and church. He was socially conservative and favored the Republican Party, although he didn't vote. He liked to watch pro wrestling and boxing but was not a big sports fan otherwise. He loved old movies, old ragtime player piano music, and Dixieland jazz. He hated ties but wore them to church. He loved old khaki pants with grass stains on the cuffs from lawn mowing. He kept me in line but also encouraged creativity, originality, and excellence in anything I did.

Spacehawk **is so visually different from the other popular science fiction comics that preceded it.** ***Spacehawk*** **looks and feels nothing like** ***Flash Gordon*** **or** ***Buck Rogers.*** **What can you tell us about your father's creative influences?**

Visually, he was influenced by Virgil Finlay, among others. He experimented with various stippling and cross-hatching techniques until he found a style that would work in comic panels—a style of shading that would not be too heavy when the pages were colored. He struggled more than some other comic artists with anatomy. The humorous stuff came easier for him—the roughs for these are spontaneous and quickly executed. His science fiction and horror comics required more accurate anatomy, however. He kept a file of Harold Foster's *Prince Valiant* Sunday strips for reference. He really worked on these from an anatomy and layout standpoint. The finished work was done in such a way that nothing was left to the imagination. It was finished—all there. So I think he was slow and laborious compared to some of his contemporaries.

There is a much darker tone to the ***Spacehawk*** **stories. Flash Gordon was never afraid to go to war against a bad guy, but whenever possible, he would try to make peace or spare his enemy's life. Spacehawk, as a character, was far less forgiving. He had zero tolerance for evil and made it his mission to hunt down intergalactic villains and kill them outright. What do you think led Basil to write his hero this way?**

My father identified with some of his characters more than others. In creating and developing Spacehawk, I think he was influenced to some degree by his faith. *Spacehawk* came at a time when my father was increasingly interested in religion. In my father's mind, Spacehawk was more than human—a combination of police, judge, jury, and executioner,

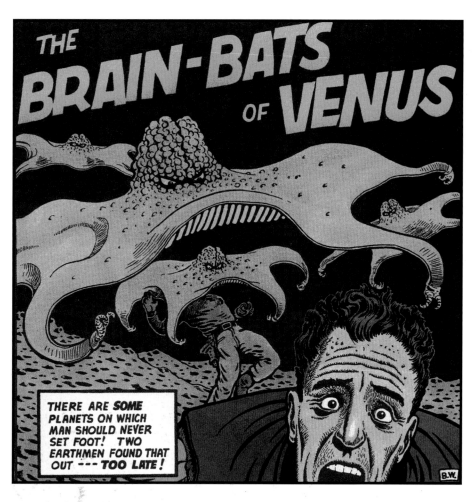

THE BRAIN-BATS OF VENUS

THERE ARE **SOME** PLANETS ON WHICH MAN SHOULD NEVER SET FOOT! TWO EARTHMEN FOUND THAT OUT --- **TOO LATE**!

Brain Bats of Venus
By Basil Wolverton

with a sort of divine authority to render life-and-death judgments against evildoers. There was no point in negotiating with the bad guys. They weren't enemies, as that implies some sort of equal footing. The real villains in *Spacehawk* stories were incorrigibly wicked—people who had given themselves entirely to evil, could not be reformed, and therefore needed to be eradicated for the good of humanity. Spacehawk had absolute moral and ethical standards and was apparently able to discern and judge people's motives. He reflected the mind-set of the World War II "builder" generation—definitely not postmodern.

In later years, Basil's publishers demanded that he remove Spacehawk's sinister-looking helmet to reveal the face of the very handsome, very American hero underneath and that Spacehawk come down to Earth and fight more pedestrian types of villains. Basil held serious objections to this but was forced to comply. He was obviously right, as this maneuver led to the slow death of the series. Why did the publishers demand this change, and how did it affect your father?

This was part of the American war propaganda machine. A lot of comic heroes of that time were fighting Nazis. Of course, Spacehawk, with his absolute sense of right and wrong, was a character ideally suited to fight the Axis powers. My father was certainly patriotic and supported the war effort, but his sense was that readers wanted an escape from the daily grind of the war and that Spacehawk would be much more helpful and entertaining to people if he were kept up in space and fighting tyrants. Certainly, the villains were often thinly disguised analogs of Hitler, Mussolini, and Tojo. But that wasn't good enough for the publishers and the propaganda office. They wanted something more literal. And once the fantastic element of space was taken from *Spacehawk*, the feature lost much of its appeal, as my father had predicted it would.

24 ZAP!

Along with *Spacehawk*, your father is also famous for drawing a lot of scary short science fiction stories for anthology comic books in the nineteen fifties. Perhaps one of the most disturbing was "The Brain Bats of Venus," about octopus-like aliens that wrap themselves around the heads of human beings and exert mind control. Many of these stories were published without writing credits. Where did these stories come from?

If you mean where did my father get the stories, I can only speculate. Some of the stories, "Robot Woman" and "End of the World," for example, reflect the paranoia of the early fifties and the cautionary idea that science was dabbling in areas it should not be, which would result in disaster for the human race—Cold War nuclear paranoia—and UFO paranoia. "They Crawl by Night" incorporated a disturbing alien-human conspiracy where people in asylums were, one by one, being turned into an army of subterranean crab people who would arise to take over the world from humankind. This bore similarities to *Invasion of the Body Snatchers* and reflected prevailing fears of Communist conspiracies. "The Man Who Never Smiled" is a relatively simple vampire story with a film noir setting. My dad was an avid film buff, having been a film critic for the *Portland News* in the late twenties and early thirties—going back into the silent era. In the late fifties and early sixties when I came home from school—at about 3 P.M., when the local TV matinee movie was aired, which at that time consisted of movies from the thirties and forties—my dad would give me a running commentary on the actors, plot, and trivia. I think he was trying to pass on his appreciation of early films. But his appreciation of films and drama definitely informed his comic work.

Considering that most of Basil's comics were aimed at young male readers, I have to ask, how old were you at the time, and did he ever throw ideas at you before-hand to see what you thought of them?

I came along in 1948, toward the end of his comic career. I barely remember him working on the early fifties horror–science fiction comics in his basement studio, which was sparsely furnished and kind of creepy down there. He never protected me from the horror stuff. I guess he thought it would have some positive effect on my developing psyche. Later, when he was doing the Bible stories, he would test some stuff out on me—and some of the *MAD* stuff—but basically he had very clear ideas of what he wanted to do and didn't feel that any market testing was needed. I got to ink a few lines of *MAD* work, but I can't remember which ones. Several times I remember him asking me to stand there while he drew my ear. He could never remember how those little folds of cartilage were arranged.

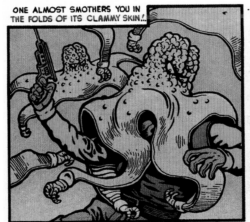
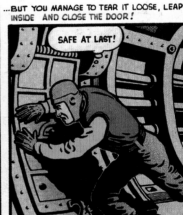
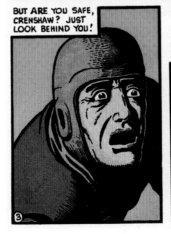
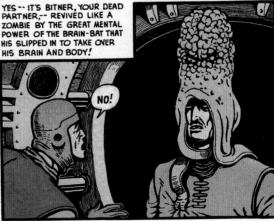

Brain Bats of Venus
By Basil Wolverton

I have often wondered why Basil never worked for the famous nineteen fifties publisher E.C. Comics. His quirky, individualistic art style would have fit right in. Can you shed any light on this or offer any theories?

I just don't know. I think they saw him as a little too off-the-wall for their adventure comics. And for the fantastic stuff, they had Wally Wood. But [E.C. publisher William M.] Gaines eventually used my dad in *MAD* for that very reason; even then they didn't want to overdo him. They just wanted to have some really strange stuff every so often. I also think that Gaines exercised a lot of creative control, and wasn't as comfortable working through the mail. They wanted artists nearby, and my dad wasn't too willing to relocate to New York City.

One of the most fascinating aspects of Basil Wolverton as an artist is that he was a deeply religious man and even worked as a preacher for a while. Yet, at the same time, he made a living drawing monsters, mutants, and bizarre, disturbing creatures. Needless to say, there are some people who might view this as some sort of moral contradiction. Did Basil ever struggle with reconciling these two different aspects of his persona, and was he ever criticized for it?

As far as I am aware, he didn't sweat a drop over it. What he didn't understand was why anyone would have a problem with it. There was nothing immoral or even suggestive about what he was doing. There were a lot of people who were just generally down on comics because they contained violence. He would answer any objections to his work along these lines, and he had more than a few such objections from various people. No one really criticized him in the church denomination in which he was involved, because of his close friendship with the church president. A couple of church executives were a bit critical, but my dad just ignored them. Yet he didn't suffer from any internal struggle to reconcile these two elements. He saw no contradiction.

Would you care to offer any final thoughts on your father's place in the history of science fiction comic art?

In science fiction comic art I see him as a bit of an aberration who pushed the envelope when it needed pushing. There really is no contemporary science fiction work that I can go to and say, "There's my dad's influence." On the other hand, when I look at animations like *SpongeBob SquarePants*, I can clearly see his influence in certain characters, like King Neptune, for example. I used to see his influence in *The Ren & Stimpy Show*. In fact, John Kricfalusi [creator of *The Ren & Stimpy Show*] told me that whenever he did some of those gross close-ups with all the detail, he was thinking of my father. In the late nineteen eighties my family and I were visiting Amsterdam, and as we were walking through a pedestrian tunnel I saw on the wall a simple face sketched by some talented graffiti artist. It could easily have passed for my father's work and was clearly derivative—I think I have a photo of it somewhere—which made me feel pretty good. I thought, "Gee, all the way over here my father's work is influencing artists." There was something intriguing about the fact that it was in a dark, dank subterranean tunnel in an ancient city in Europe.

Crash Landing
Even after a horrible crash,
you'd better be prepared.
By David Hartman

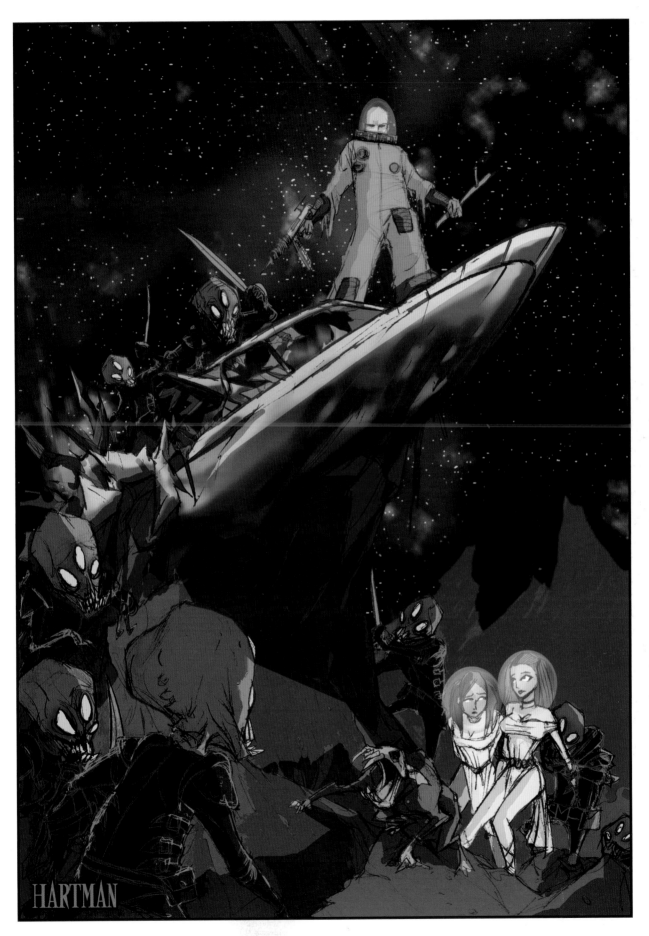

E.C. COMICS

Sci-fi comics took on a dynamic new look in the 1950s thanks to William M. Gaines' comic book company E.C. Comics. With titles such as *Weird Science* and *Weird Science Fantasy*, Gaines and his crew printed bizarre sci-fi stories that satisfied and reflected their tastes in the genre. They did not use continuing characters and storylines like *Buck Rogers, Flash Gordon,* or *Spacehawk*. The E.C. Comics strategy was to publish anthology comics that contained five original, unrelated short stories per issue. The excellent writing and artwork hooked readers and kept them coming back. Gaines and his top staff writer-artist, Al Feldstein, were responsible for turning out most of the stories.

Although they were brilliant storytellers in their own right, Gaines and Feldstein soon found their imaginations exhausted by the tremendous number of original stories they needed to fill their monthly sci-fi, horror, and crime anthology comics. As a way of lightening the workload, they occasionally borrowed ideas from stories they found in sci-fi pulp magazines. The exciting work from a new sci-fi author named Ray Bradbury quickly caught their eye and gave them inspiration. In fact, some might argue that Gaines and Feldstein drew a little too much inspiration from Bradbury. One of the most endearing E.C. Comics-Bradbury anecdotes concerns an E.C. yarn entitled "Home to Stay." The story, though good in its own right, was actually a thinly disguised rip-off of two of Ray Bradbury's short stories, "The Rocket Man" and "Kaleidoscope." When the comic book was published and Bradbury read it, he was neither angry nor upset. He simply wrote a letter to Gaines and Feldstein stating that he was pleased with the quality of "Home to Stay" but reminded them that they had forgotten to pay him for permission to adapt his work. He also asked that they remember to print his name on any future adaptations. Knowing that the clever writer could certainly sue E.C. Comics for plagiarism if he wanted to, Gaines responded by immediately mailing Bradbury payment for the story and made a deal to publish several "official" future adaptations of his work with, of course, full credit. Thus, a very friendly agreement was struck. Bradbury made no secret of the fact that he enjoyed and respected the quality of E.C. Comics. And in return, printing the name of the increasingly popular author on their covers became a helpful selling point for E.C. Comics.

The artists who illustrated E.C.'s sci-fi comics were among the best in the business. Al Feldstein produced some startling cover illustrations, as did Joe Orlando, Frank Frazetta, Harvey Kurtzman, and Jack Davis. But without question, the two artists who stole the show and were most responsible for developing the influential look and style of E.C.'s science fiction line were Al Williamson and Wallace "Wally" Wood.

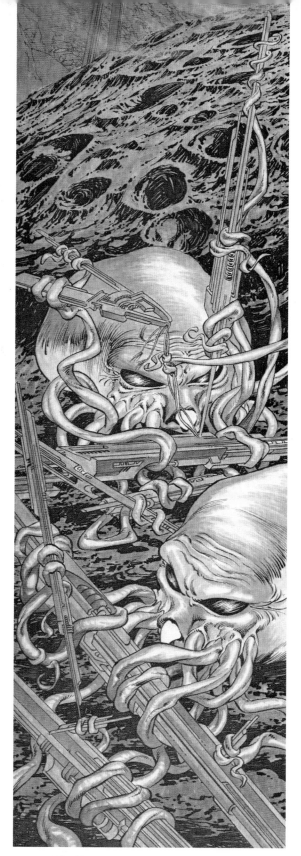

Octopoid Aliens
By Bernie Wrightson

▶ **Cosmic Encounter**
You never know what you may come across when exploring alien worlds.
By Bryan Baugh

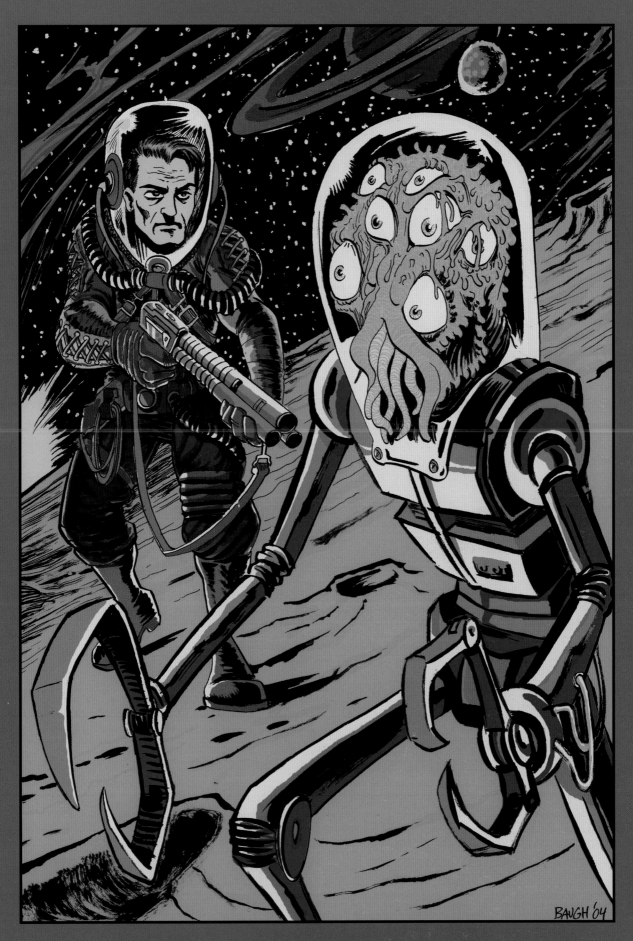

Al Williamson

Al Williamson discovered science fiction during his early childhood while watching Universal Studios' Flash Gordon serial films in the theater. He soon became a devoted fan of Alex Raymond's Flash Gordon comic strip, which, in turn, inspired him to become an artist. By the time he was in his twenties and working for E.C. Comics, Williamson had already developed a style reminiscent of his great inspiration and yet unique unto itself. The spirit of Alex Raymond echoes through Williamson's cosmic heroes, glamorous intergalactic maidens, sleekly rounded spaceships, and vast, futuristic cities, glimpsed through tattered foreground foliage. His other inspirations included Hal Foster and Burne Hogarth, the two great artists of the classic Tarzan comic strips, with their strong emphasis on dynamic figures, and fellow E.C. Comics artist Wallace Wood, famous for his heavily detailed space suits and complex pieces of futuristic gadgetry. Williamson's work is a great example of classic space opera, with his jungle planets populated with beautifully rendered dinosaurs and high-tech heroes riding toward adventure on the backs of giant galloping lizard creatures.

In his post–E.C. Comics years of the 1960s, Williamson accomplished a childhood dream of illustrating a new series of *Flash Gordon* books for the publisher King Comics. Although a string of talented artists had taken over the Flash character since Alex Raymond's passing, no one captured Raymond's vision more precisely than Al Williamson. And in some respects, Williamson's work carried that vision even farther. Williamson transformed Raymond's alien villains, which tended to look like scary humans with odd skin colorations, excessive body hair, and an occasional set of horns, into more elaborate creatures. When Flash Gordon visits an underwater city in a Williamson illustrated story, the aquatic denizens are not just bald, green-skinned men holding tridents, but fish-faced monsters.

Another of Williamson's prominent accomplishments in the world of sci-fi comic art came in the late 1970s and early 1980s, when he was handpicked by George Lucas to illustrate Marvel Comics' adaptations of the *Star Wars* films. Williamson was unavailable for the first adaptation, *Episode 4: A New Hope,* but did a stunning job on *Episode 5: The Empire Strikes Back,* and *Episode 6: Return of the Jedi.* It has been said that because Lucas was a reader of sci-fi comics as a youth, he based much of the look and style of his *Star Wars* films on Williamson's work. Official Lucasfilm publications have also claimed that a major sequence in *Episode 3: Revenge of the Sith,* in which hero Obi-Wan Kenobi rides into battle on a giant fast-running lizard, was deliberately based on a Williamson illustration.

Al Williamson continued working on comic books into the 1990s. One of his noteworthy projects during that decade was a two-part Flash Gordon comic book miniseries written by Mark Schultz and published by Marvel Comics. In 2003, publisher Mark Wheatley released the art book *Al Williamson Adventures,* which features a number of short comic stories and illustrations printed in large format. The book offers a glorious display of Williamson's work—all of which looks just as powerful today as it ever has. I recently had the pleasure of interviewing Al Williamson.

▶ **Space Hero Fighting Alien Pterodactyl**
By Al Williamson

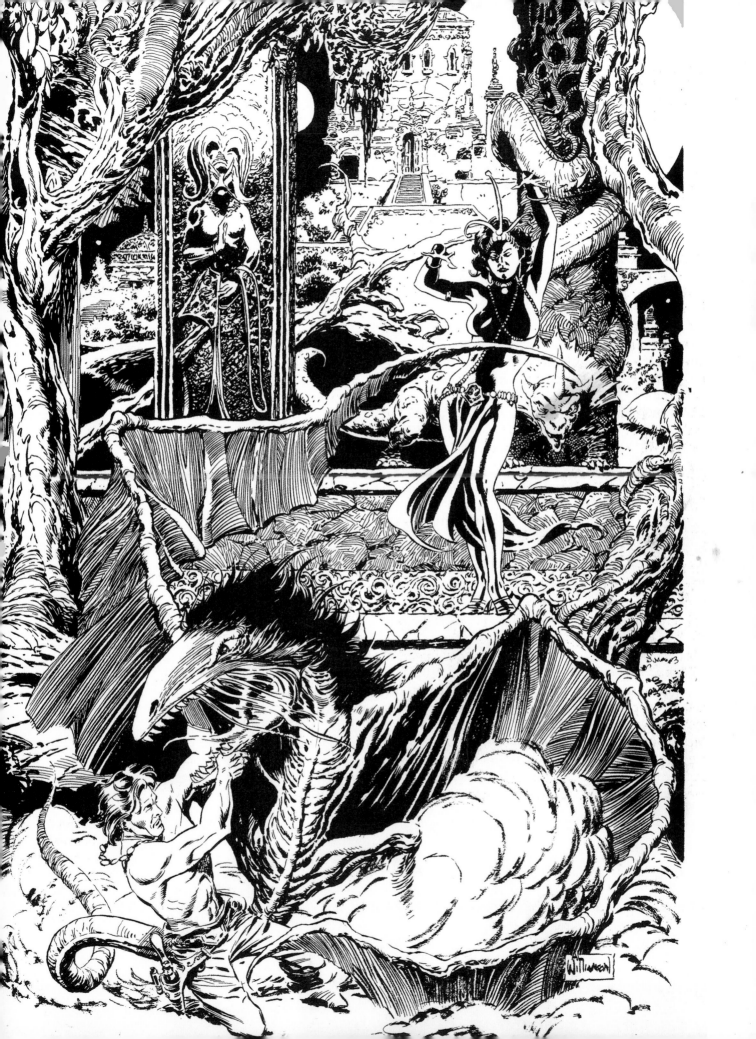

AN INTERVIEW WITH
AL WILLIAMSON

What was it that attracted you to the genre of science fiction as a means to express yourself as an artist, and not to superheroes, horror, sword and sorcery, westerns, or other popular comic book subjects?

When I was nine or ten years old, I started collecting the Mexican comic book *Paquín*, which contained comics from the United States, including *Buck Rogers*—which I particularly liked. I was living in Colombia at the time, and my mother took me to see the *Flash Gordon* serials at the movies. The serials got me interested in looking at the *Flash Gordon* Sunday pages by Alex Raymond. The more I looked at Alex's work, the more I liked his drawing. I learned how to draw figures by studying Alex's work.

In your experience, what have you found to be the most enjoyable aspect of drawing science fiction comics, and what do you find to be the most challenging?

I love science fiction and the fact you can make up what people look like on different planets. I don't think of the process as challenging—it's just fun.

The overwhelming majority of comic fans, artists, and critics hold your work for E.C. Comics in very high regard. Yet based on other interviews I've read, it seems that over the years you have gone back and forth in your opinions of that material. If I were to ask for your final statement on your E.C. work, what would it be?

I don't think my E.C. work would have been as good if I didn't have my good friend Roy Krenkel helping me with the backgrounds. I never thought much of the work that I did in my early twenties for E.C., but felt that since Bill Gaines kept giving me work I guessed it was okay. Now I look at it, and it looks better to me than I remembered. Overall, I think that for being a young artist I did a fairly good job.

Of all the great projects you've worked on over the course of your career, which one are you the most proud of, and why?

I enjoyed all the work I did. I was happy to be a cartoonist. It was something I wanted to do since I was twelve years old. It is hard to pick one job, but I guess I would pick the *Flash Gordon* books, followed by *Star Wars*. It was exciting to do Flash Gordon because it was a character Raymond had created and drawn. *Star Wars* was fun because I loved the movie. Archie Goodwin, my good friend, wrote the scripts so well. I think he captured the feeling of the movies and characters and made my job more fun.

In your opinion, what established artists do you think young, hopeful science fiction artists should make time to look at and learn from?

I think Mark Schultz and Gary Gianni are two of the best.

What would you say has been your biggest struggle as an artist? And how have you overcome it?

I have always felt my work could be better. When I look at it after time has passed, I realize it was okay. I have been pretty good about meeting my deadlines. The deadlines haven't

given me much time to agonize over the work. My motto has been "Do the best job you can and meet the deadlines."

What would you say is your greatest strength as an artist?

Enjoying what I do.

In the mid–nineteen nineties you returned to Flash Gordon with an exciting two-issue miniseries written by Mark Schultz and illustrated by you for Marvel Comics. Is there any chance that you will draw more Flash Gordon adventures in the future?

I don't know. If given the chance I probably would, but Mark would have to write it.

What would be the single most important piece of advice that you would give to a young person who hopes to someday become a professional comic book artist?

Love what you do and take life drawing classes.

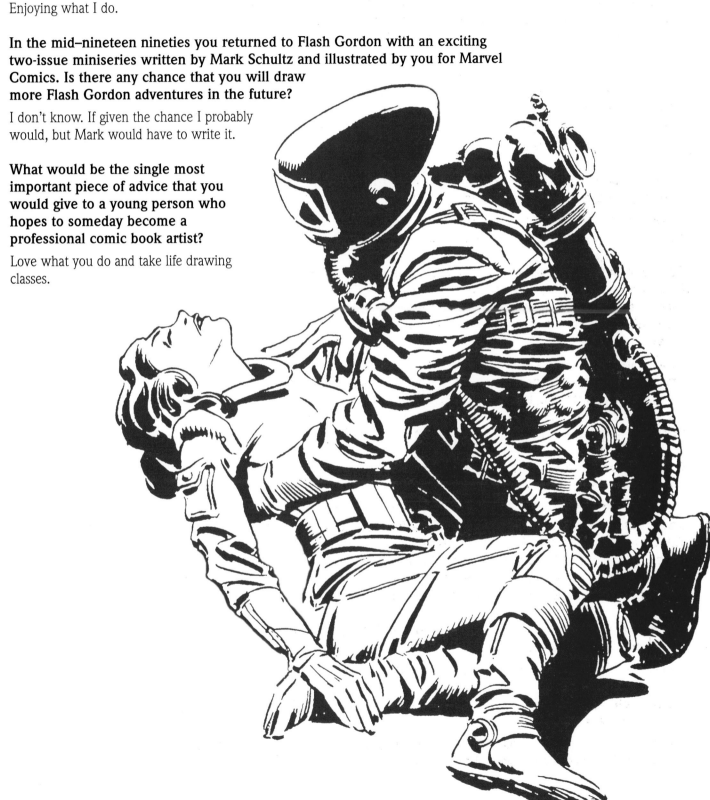

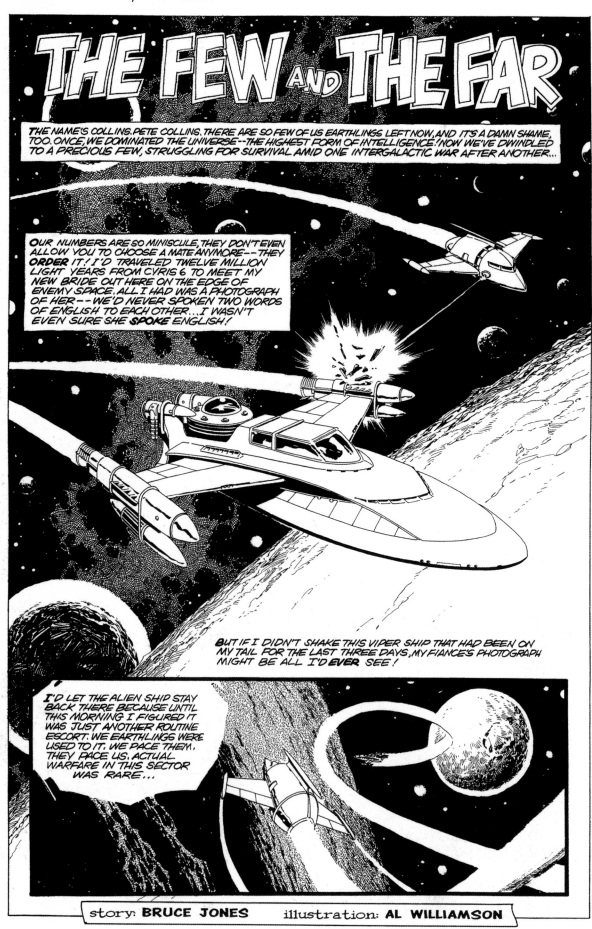

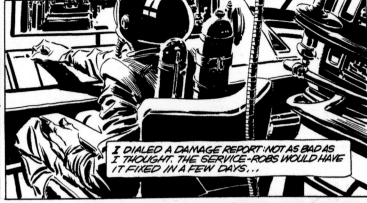

I DIALED A DAMAGE REPORT: NOT AS BAD AS I THOUGHT. THE SERVICE-ROBS WOULD HAVE IT FIXED IN A FEW DAYS...

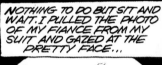

NOTHING TO DO BUT SIT AND WAIT. I PULLED THE PHOTO OF MY FIANCE FROM MY SUIT AND GAZED AT THE PRETTY FACE...

THAT'S WHEN I HEARD THE NOISE OUTSIDE...

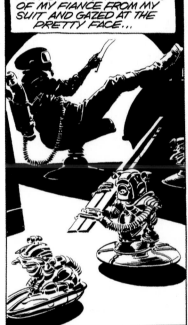

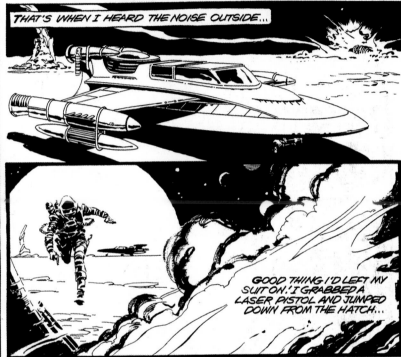

GOOD THING I'D LEFT MY SUIT ON.' I GRABBED A LASER PISTOL AND JUMPED DOWN FROM THE HATCH...

MY SUIT SENSORS SHOWED THE PILOT WAS STILL BREATHING BUT NOT IN ANY CONDITION TO PUT UP A FIGHT. I APPROACHED CAUTIOUSLY...

I TWISTED OFF THE HELMET AND NEARLY DROPPED MY TEETH!

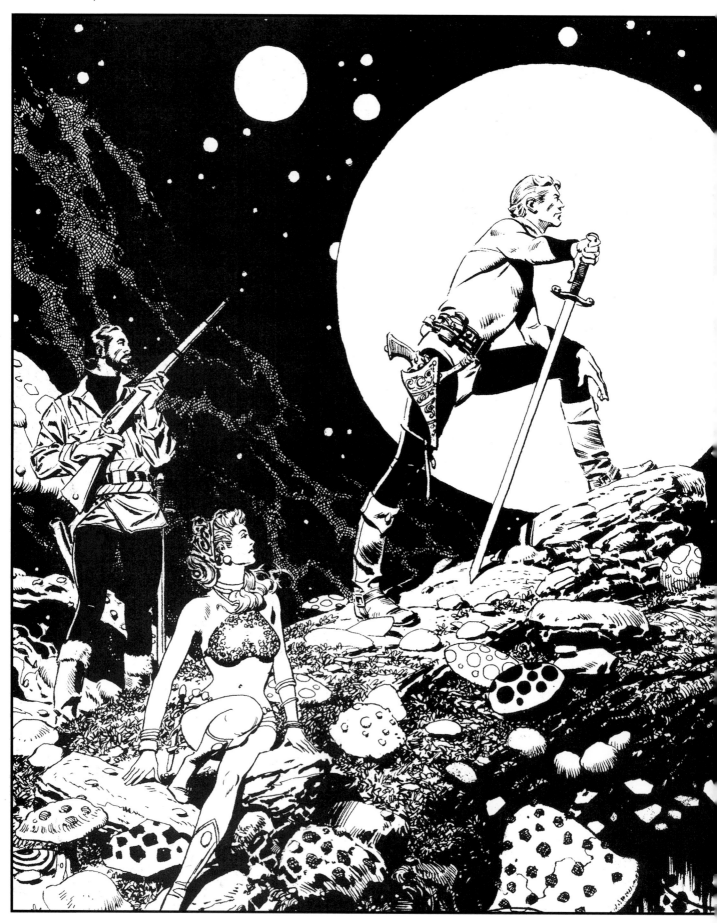

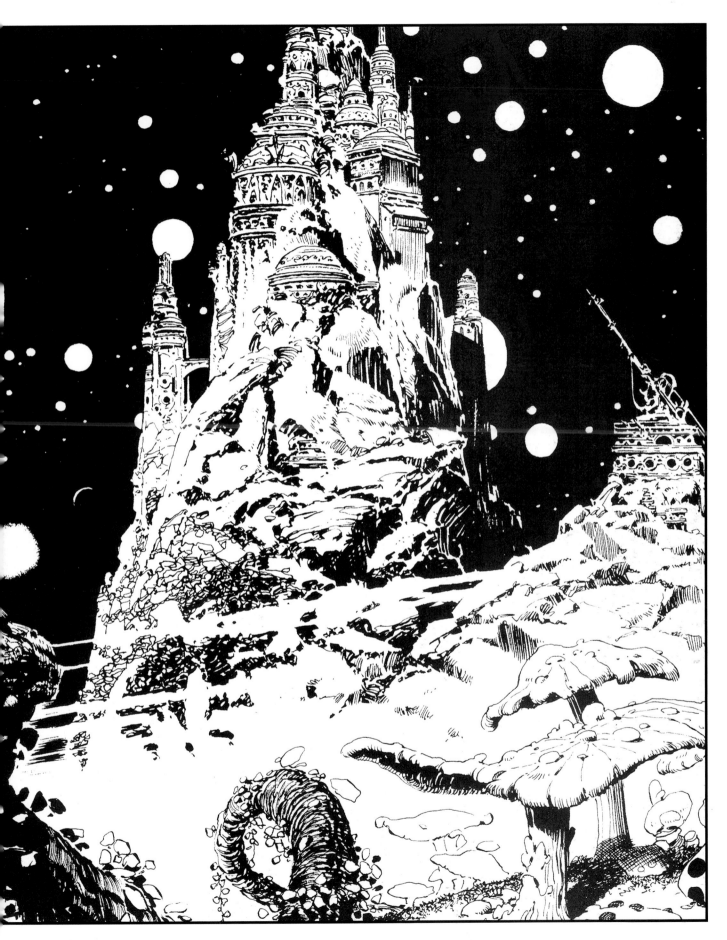

Wallace "Wally" Wood

There is perhaps no artist more singularly responsible for the look and style of science fiction comic books in the 1950s than the great Wally Wood. He was not interested in making sci-fi look glamorous as were artists such as Alex Raymond, who specialized in bringing out the glorious, romantic, operatic, and fantastic aspects of science fiction. Wood's vision was more tactile—a nuts-and-bolts kind of approach. His spacecrafts were not the smooth, aesthetically pleasing, art deco missiles of the 1930s, but gigantic vessels with rivet-studded interiors and exposed, complex engine parts. Even when he drew a more classic-looking, streamlined chrome rocket, he made a point of equipping it with large, swept-out tailfins and heavy-duty thrusters. His space heroes were squinting tough guys who looked less like Flash Gordon and more like gritty World War II infantrymen heading into battle, with stubble on their chins and mud on their boots. Also, Wood's sci-fi characters never wore uniforms with capes, Robin Hood hats, or upturned collars. They wore astronaut suits—unflattering, but practical looking and believable—with imposing helmets; bulky, scuba-style air tubes snaking over their shoulders; chest plates with sprouting wires; and thick straps supporting heavy backpacks. Wood obviously reveled in detailing this equipment in all of its greasy, mechanical glory.

Wood was a master of adding just the right details to his imaginative creations to make them look convincingly real. It would not be unusual for Wood's astronauts to have an extra pair of work gloves hooked over a utility belt or a spare oilcloth flapping from a pocket. His spaceship and laboratory interiors were always layered with gadgetry, tangled electrical cables, rows of arching steel girders, and control boards covered with switches and knobs. His alien planets were either rocky, cratered surfaces with multiple moons floating in the sky or lush jungle environments brimming with exotic foliage, bizarre mushrooms, slithering lizards, and, invariably, a random log, stick, or tree, on which he jokingly inscribed his last name.

Wood also drew some of the most grotesque aliens ever to have appeared in comic book history. He was an absolute master of the 1950s BEM (bug-eyed monster; *see* "The Emotional Approach," on page 106) style of slimy, slobbering space creatures. If there was one aspect of Wood's sci-fi art that recalled the more glamorous approach taken by his seniors, it would most definitely be his women characters. Wood's women were as sultry and beautiful as his aliens were horrible and grotesque. Occasionally, he would have the heroine wear the same clunky space suit as the male character. However, whenever possible, he—or his writers—found excuses to present the standard, knockout Wood female in sensual, semitransparent space gowns.

During his time at E.C., Wood was frequently assigned to illustrate stories that focused on the darker, scarier aspects of sci-fi. The fact that Wood's real life was rather dark itself may explain why he was so well suited to the job. A classic example of the tortured artist, Wood had a ferociously self-destructive streak to his personality. Aside from being both an alcoholic and a chain-smoker, Wood was also a feverish workaholic who was known to regularly pull two- and three-day marathons of nonstop drawing—without sleep—in order to produce the best art possible and meet his deadlines. Naturally, this behavior often left him exhausted and depressed. And being a perfectionist, he tended to agonize over what he perceived to be the weaknesses in his art, while never acknowledging its considerable strengths. He enjoyed some success—and some say performed his finest work—on *MAD* magazine in the late 1950s and early 1960s. A personal project entitled *Witzend*, which he created, wrote, illustrated, and self-published, was not received as well as he had hoped, and Wood viewed it as a major failure. As the years wore on, Wood found plenty of commercial illustration opportunities in the advertising business, but his overall outlook became more and more gloomy. At one point he was quoted as saying, "Do not seek to be a creative writer or artist. Do not care about doing anything good. That will only put you at the mercy of those who will always hate you because you can do something they can't." After suffering from eye problems and kidney failure due to years of hard drinking, Wood committed suicide in 1981.

This illustration demonstrates Wally Wood's mastery of science fiction art. Notice the details in the foreground character and the background. By Wally Wood. Copyright © William M. Gaines, Agent, Inc.

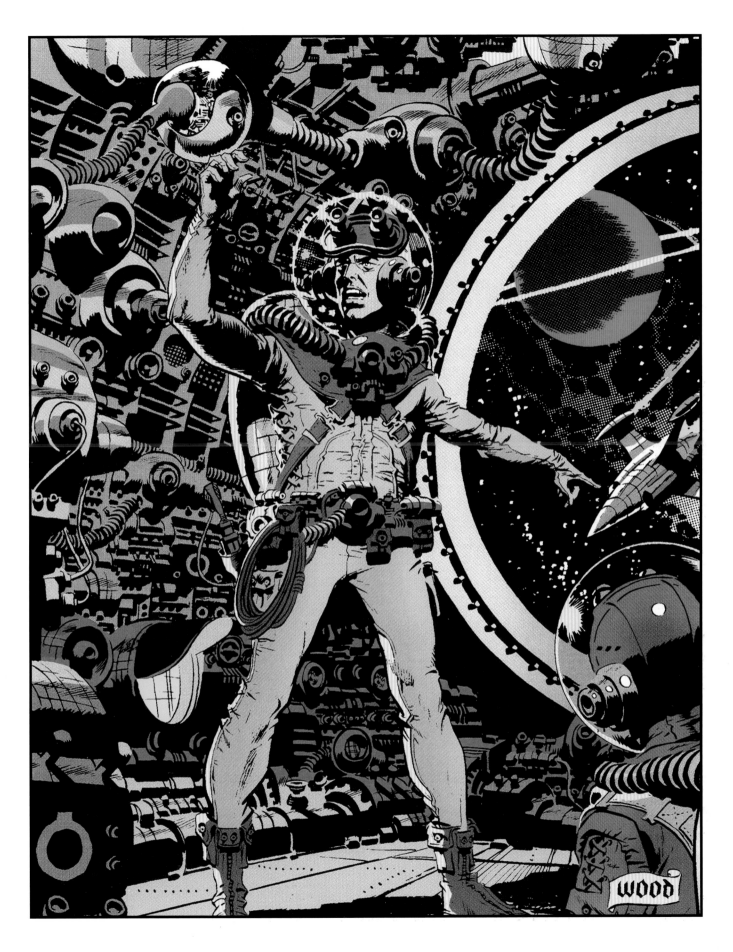

RUSTY ROBOTS AND RUN-DOWN SPACESHIPS

In 1977 a film premiered that would change science fiction forever and whose influence would eventually transform the look of sci-fi in every visual entertainment medium. That film was *Star Wars*, created, written, directed, and produced by George Lucas. Presenting audiences with something they had never quite seen before on a movie screen, *Star Wars* was an outer-space adventure film set in an imaginary galaxy that somehow looked convincingly real.

A major component of this realistic look was not only the use of revolutionary special effects techniques but also Lucas' brilliant depiction of what he called a "used universe." This technique, partially drawn from the E.C. sci-fi comics that Lucas read as a child, was nevertheless a major innovation. Instead of the usual clean, smooth, and pristine sci-fi world, Lucas gave the audience fantastically designed robots and spaceships whose surface details were flawed with dents, scrapes, chipped paint, exhaust burns, oil smudges, discolored replacement parts, and rust. Amusingly, most of the spaceships in *Star Wars* were depicted as running about as well as a junky old car. In fact, a running gag throughout the film—and its sequels—has various characters cracking jokes and poking fun at the subpar performance of various space vehicles and referring to them as "buckets of bolts" and "hunks of junk." Lucas even went so far as to instruct his sound effects designer, Ben Burtt, to use the sounds of rusty doors, grinding gears, chugging engines, and malfunctioning machinery with the film's futuristic technology. The result was a completely make-believe sci-fi world that had a gritty, real-life feeling. The influence of *Star Wars*, especially its visual style, casts a long shadow and has clearly had a powerful effect on sci-fi films and comic books ever since. Consequently, there is a drastic difference in the look of sci-fi works that appeared before and after the late 1970s.

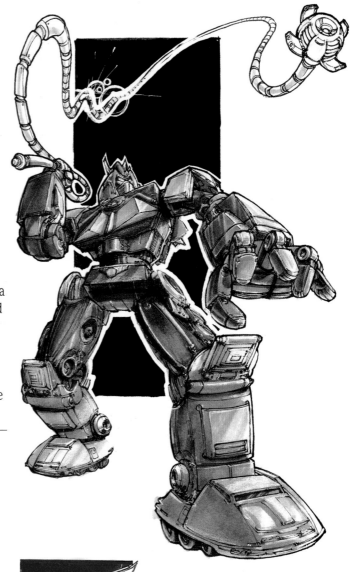

▲ **WhipBot**
A futuristic machine using a very primitive weapon.
By Jojo Aguilar

Spaceship 1
A small, three-winged spacecraft. By Jojo Aguilar

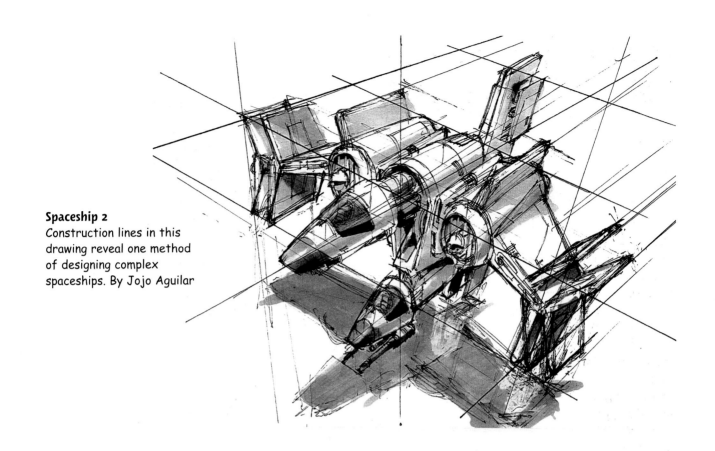

Spaceship 2
Construction lines in this drawing reveal one method of designing complex spaceships. By Jojo Aguilar

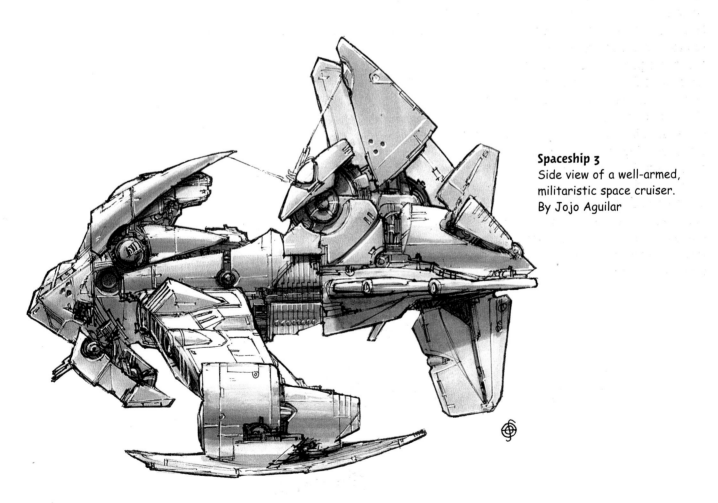

Spaceship 3
Side view of a well-armed, militaristic space cruiser. By Jojo Aguilar

PART TWO
DRAWING SCI-FI CHARACTERS

Drawing characters for sci-fi comics can be a very fun, and very challenging, creative experience. It requires a certain strict dedication to basic drawing, yet also offers plenty of room for freewheeling creativity and imagination. The following section demonstrates this and offers examples of different types of sci-fi characters, from those that are very close to basic figures to those on the furthest fringes of fantasy.

Meeting a Multi-Eyed Monster
Yikes! This is why you should never go wandering around an alien planet on your own. A Multi-Eyed Monster definitely has its sights set on this hapless astronaut. By Bryan Baugh

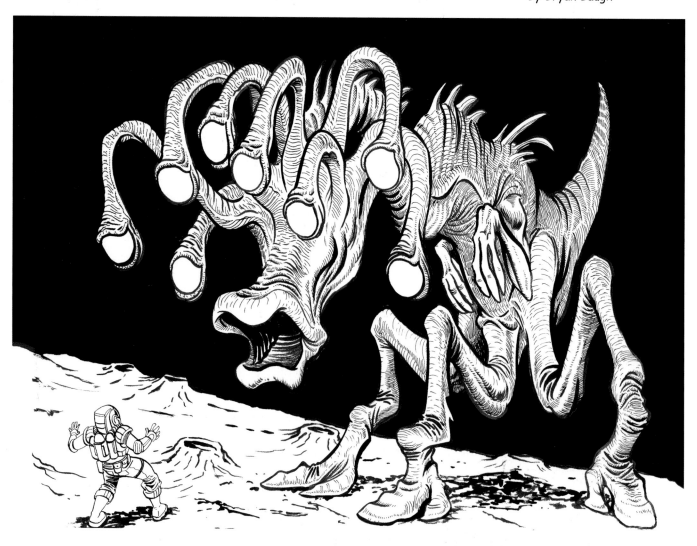

SCI-FI COSTUMES

Costumes are a fun aspect of drawing sci-fi characters. Reviewing successful science fiction works of the past shows that in outer space, characters, whether good or evil, can wear a wide variety of costumes. A costume can be strikingly simple, like Flash Gordon's sleekly militaristic fatigues and Han Solo's black and white vest-and-trousers outfit. Or a costume can be heaped with complex gadgetry and futuristic detail, like John Carter of Mars, with his flaring capes and extravagant, alien adornments; or Boba Fett, with his colorful, weapon-covered armor; or any of the tough-looking astronauts drawn by Wally Wood for the E.C. Comics, with their space suits cluttered with overlapping air-tubes, utility belts, and rivet-studded hardware. Knowing what kind of costume will best suit your character is a matter of knowing your character's personality. Consider the type of character you are creating before you draw them. Ask yourself: What is his/her job? Is your male character a space pirate, a science officer, or an intergalactic warlord? Is your female character a space princess, a space witch, or a space waitress? What sort of environment do they come from? What other planets have they visited in the past? What sort of adventures will they experience? A solid understanding of your character will tell you exactly what sort of outfit to put them in. It will also tell you what sort of outfit *not* to put them in. A practical-minded cynic like Han Solo would look pretty ridiculous in John Carter's loud, Byzantine attire, for example.

Maybe you want to create great-looking costumes for your sci-fi characters, but don't want them to look like things you've already seen in other comics and movies. If so, that's a great instinct—it means you have a desire for originality and want to create something in a unique style. There's a wide range of inspiring sources right here on Earth that can help you make your sci-fi creations totally unique. If you want to draw a new kind of futuristic spacesuit, try looking at photos of real astronaut suits. They have many strange details. You can incorporate the parts you like into your drawing and forget the ones you don't. And who says you should only look at astronaut suits? What about antique diving suits? Or fighter pilot uniforms? Find pictures of them and have fun borrowing and combining the best parts. Another neat trick is to look at exotic styles of clothing from other countries or bygone eras, and then incorporate those elements into your imaginary creations. In 1979, the French comic book artist Moebius was hired as a production designer for Ridley Scott's film *Alien*. There's a scene in the film where a group of explorers land on a strange planet and go out in their space suits to examine the wreckage of a crashed alien ship. Although the film was supposed to take place roughly one hundred years in the future, Moebius based the design of the space suits on 16th century Japanese samurai battle armor. The result, as seen in the final film, is quite brilliant. Moebius makes it easy to believe that we're seeing a real, functioning

Space Drone
A mysterious warrior from an unknown world.
By Bryan Baugh

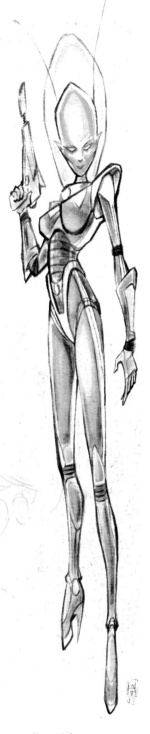

AlienGirl
An attractive specimen of female alien life.
By Bill Bronson

space suit that comes from a time and place completely different from our own. By the same token, Alex Raymond based the look of his *Flash Gordon* comic strips on art deco, a design style that was enormously popular in the 1920s and 1930s. George Lucas, a huge *Flash Gordon* fan, has said that the look of his films was also based on this same early twentieth-century aesthetic.

In the 1970s, the popular science fiction television series *Battlestar Galactica* based many of its design elements on ancient Egyptian themes. The show featured, among other details, space pilots' helmets that closely resembled King Tut's striped headdress and villainous fighter ships shaped like Egyptian scarab beetles.

Certainly, medieval European styles have also influenced the look of many sci-fi works—consider all those armored space knights. The skimpy costumes worn by space princesses are usually inspired by Arabian belly dancer or harem girl motifs. On the other hand, in both the comic book and 1960s movie adaptation of *Barbarella*—widely considered the ultimate example of the "sexy space girl" concept—the costumes seem to have been inspired by Las Vegas showgirl attire.

There are many examples of this technique that we could talk about, but I think you get the idea. No matter how imaginary the subject of your drawing, you may actually find your best details in the real world.

▶ **Alien Abduction**
It seems some aliens are as curious about us as we are about them. By Bill Bronson

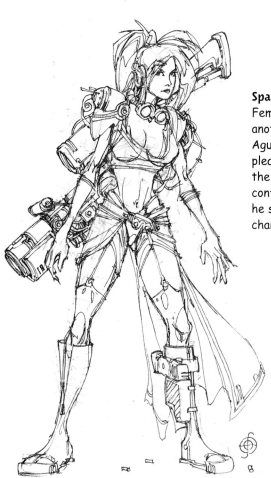

Space Girl 1
Female warrior from another world. Jojo Aguilar's work is such a pleasure to look at. Notice the loose, energetic, confident lines with which he sketches out his characters. By Jojo Aguilar

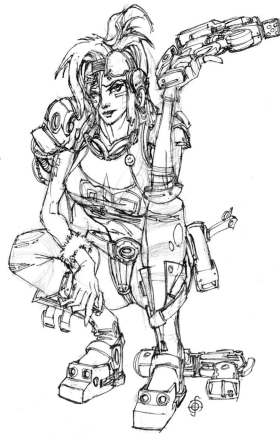

Space Girl 2
In the distant future, you might think twice before hitting on a pretty lady with a laser gun. By Jojo Aguilar

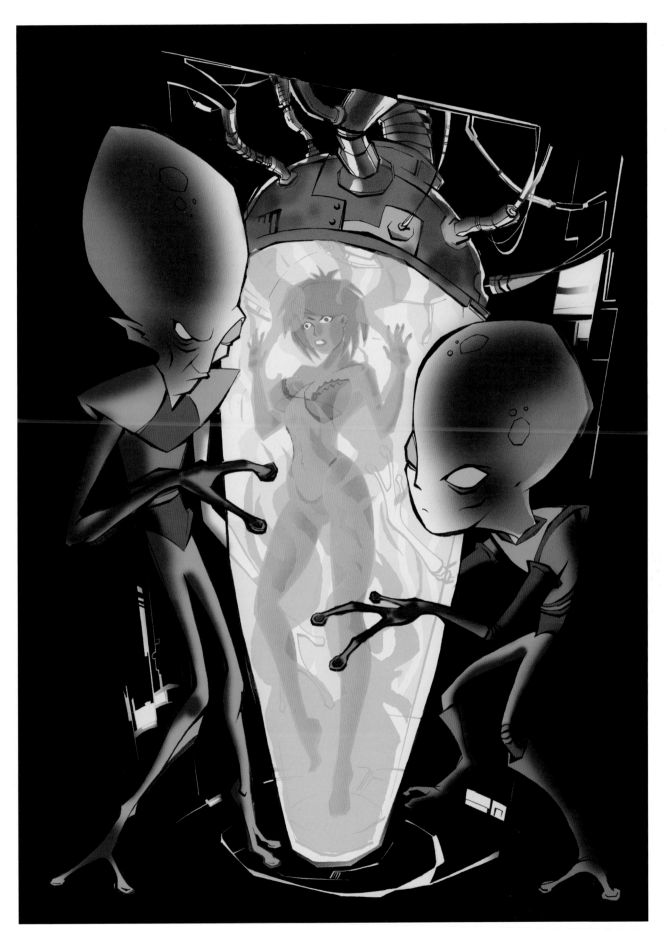

HUMANS

The desire to expand our territory and explore unknown regions is an integral part of human nature. At present, humans have already journeyed into space and to the Earth's moon. In the future, we may be able to physically explore other planets, solar systems, and galaxies . . . perhaps one day we may even reach other dimensions. Some will go for the sake of humankind, some will go in the name of science, and some will go simply for the thrill of adventure. This chapter is an excellent starting place for the beginning artist to learn how to draw interesting sci-fi characters, as all of the characters included in this section are basic human figures to which lots of fancy costumes and decorations have been added.

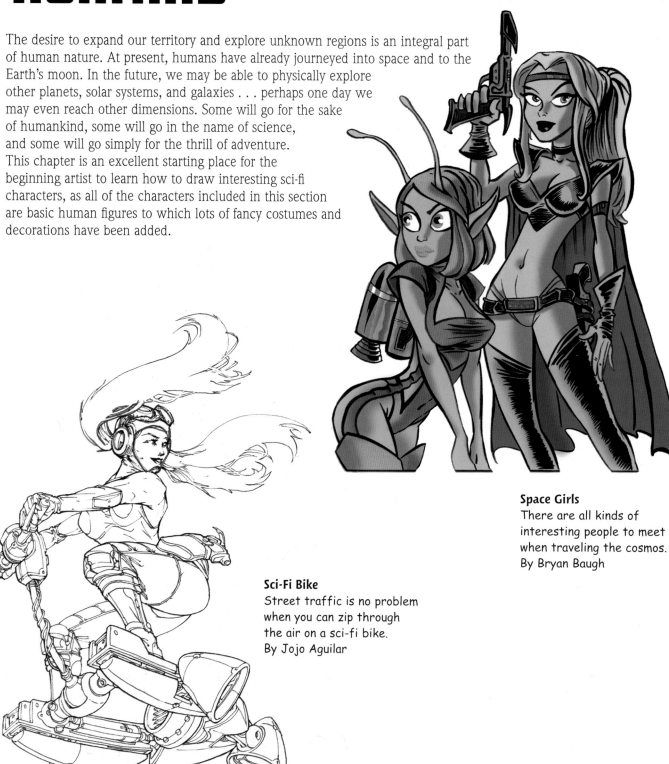

Space Girls
There are all kinds of interesting people to meet when traveling the cosmos. By Bryan Baugh

Sci-Fi Bike
Street traffic is no problem when you can zip through the air on a sci-fi bike. By Jojo Aguilar

Dedicated Scientist

No successful mission to outer space would be possible without him. If not for his obsessive tinkering, there would be no space suits, no laser weapons, no robotic assistants, no time machines, not even spaceships. All of that hardware had to be invented, and here's the guy who did it. If you can handle drawing a basic human form, you should have no problem.

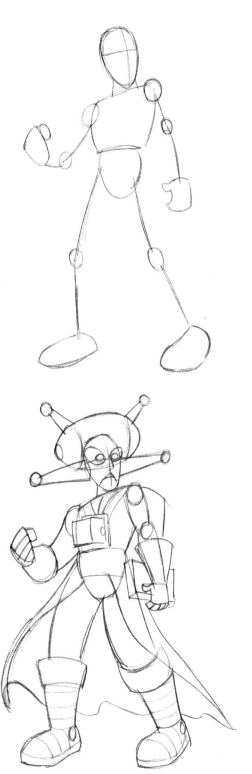

Don't go too superheroic with this character. There's no reason to exaggerate his musculature. Remember, the scientist is just a regular guy. But give him a well-trimmed goatee or beard and mustache to make him look dignified. Pay attention to the shape of the eyes, the arch of the eyebrows, the downturned mouth, as these details reveal a bold personality. All the equipment isn't as complicated as it looks. Break it down into simple forms, and you'll see it's really nothing more than cubes and cylinders.

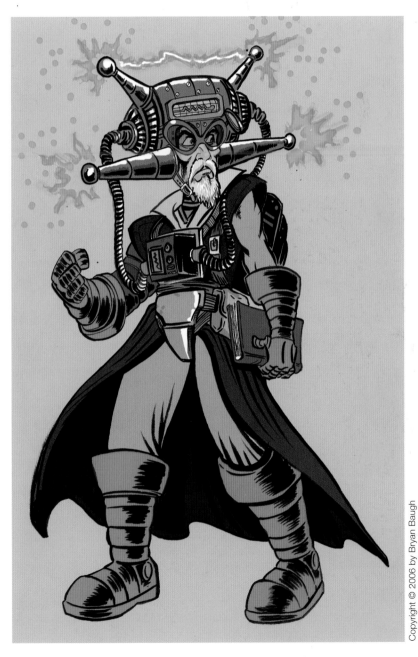

Space Hero

Going into space and exploring alien worlds is not a safe and easy job, but this guy is prepared. The fun of drawing this space hero is, of course, detailing his costume. But remember, you want to start out with a basic human figure. Skipping this essential first step would be like trying to build a house without laying a foundation.

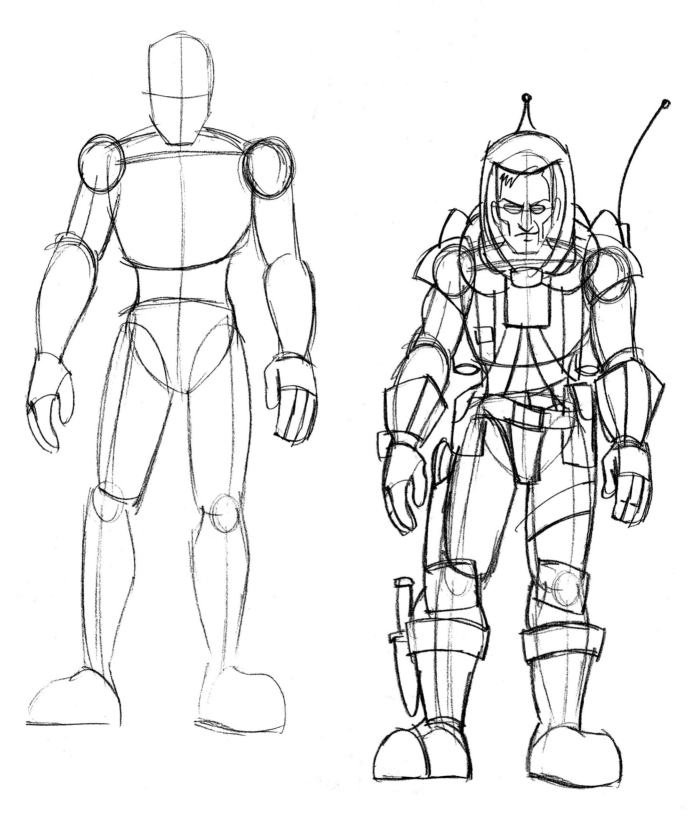

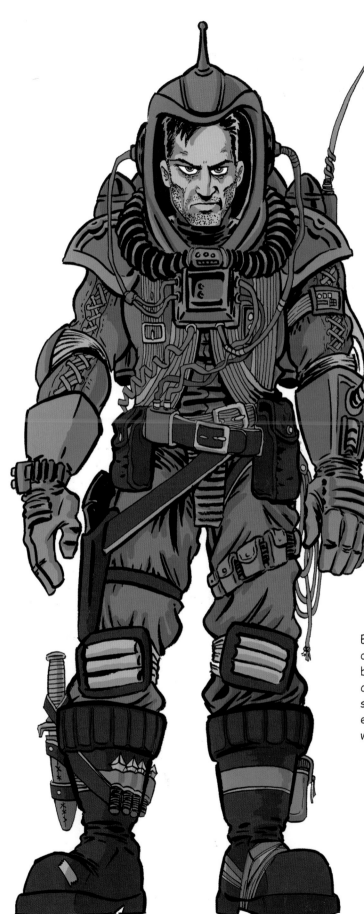

Establish the size and shape of the head before you draw the helmet, and decide on the build of his body before adding the rumpled space suit. Don't cheat! Break the human figure down into simple shapes first and then have fun adding on all the exotic gadgets, utility belts, wires, air tubes, and weapons.

Space Pirate

Some guys enjoy space more than Earth and decide to roam among the stars, seeking intergalactic adventure and fortune. After visiting so many different worlds, the space pirate has developed a costume that combines parts of his old Earth clothing with various exotic alien accessories. Here's where you can have fun using classic superhero drawing techniques.

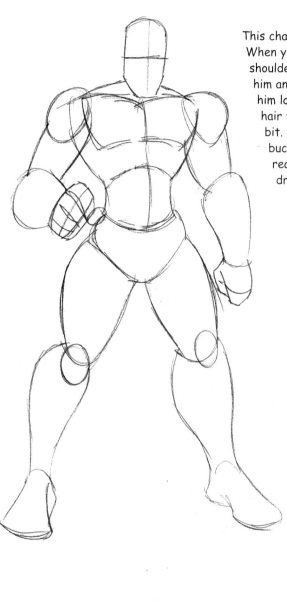

This character is all about exaggeration for dynamic, heroic effect. When you lay out his basic form, also try to exaggerate the width of his shoulders, the breadth of his chest, and the size of his muscles. Give him an impressive stance, with his feet planted far apart—which makes him look heavier. When you start adding the surface details, make his hair flow to one side, as if blowing in the wind. Make his cape flare a bit. I added gun belts, spikes (or are they alien teeth?), pants, and buccaneer boots. However, these are just fun details. When you reach this point, don't feel that you have to copy exactly what I drew. Try to design your own costume for your space pirate.

Space Mercenary

This cosmic adventurer can be hired to take on a number of risky, interplanetary odd jobs. Pay him well, and he'll transport you across the galaxy in his spaceship, embark on dangerous rescue missions, smuggle goods, find treasures, or even fight a war. Just be careful. If he thinks there is more to gain by simply robbing and then leaving you stranded somewhere in deep space, he might just do it.

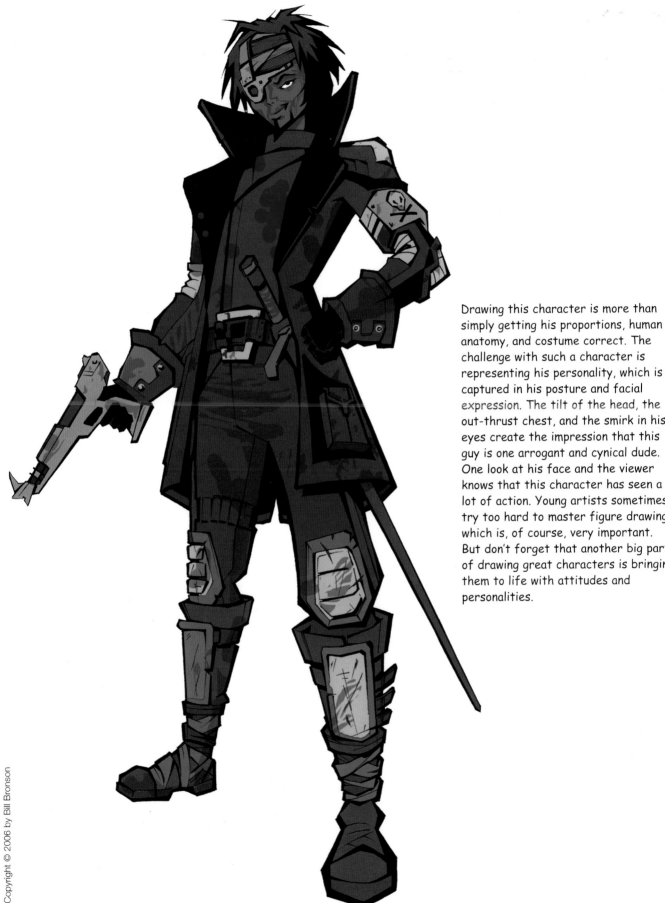

Drawing this character is more than simply getting his proportions, human anatomy, and costume correct. The challenge with such a character is representing his personality, which is captured in his posture and facial expression. The tilt of the head, the out-thrust chest, and the smirk in his eyes create the impression that this guy is one arrogant and cynical dude. One look at his face and the viewer knows that this character has seen a lot of action. Young artists sometimes try too hard to master figure drawing, which is, of course, very important. But don't forget that another big part of drawing great characters is bringing them to life with attitudes and personalities.

Intergalactic Astronaut

The Intergalactic Astronaut makes it his job to travel into the unknown and explore alien worlds. Therefore, he wears a rugged space suit and equipment designed for tackling any sort of situation, enemy, or interplanetary environment. Again, this is an exercise in drawing a basic human figure and then adding a lot of interesting accessories. With a character like this, covered with bulky space equipment, some artists may think they do not need to worry about laying out the basic human figure beforehand. They may be so excited about drawing the cool-looking space suit that they start drawing the shapes of the equipment and then attach the arms and legs as they go.

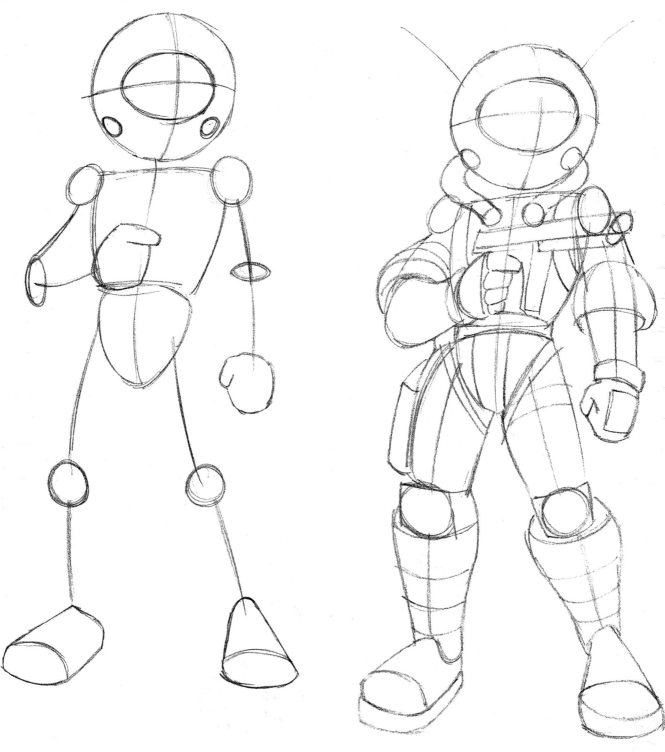

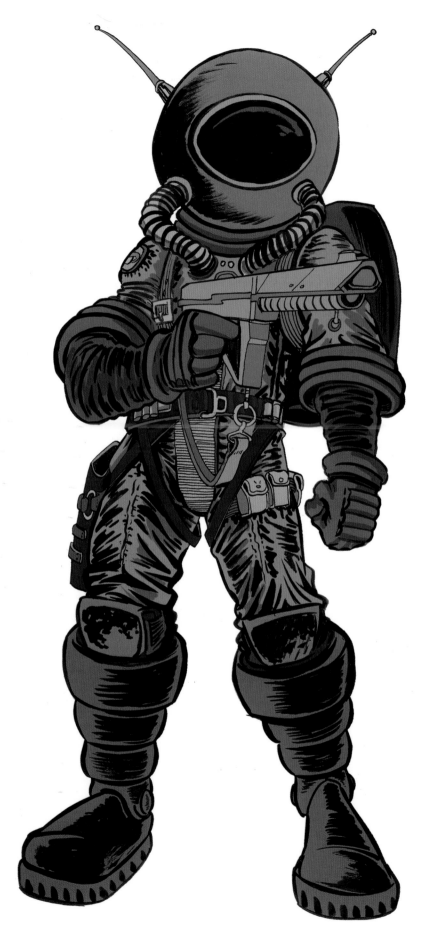

Don't be lazy and go looking for shortcuts. I can't stress enough that establishing a solid, well-proportioned figure is a mandatory first step when drawing any type of character, regardless of the outfit. Years down the road, when you've had plenty of practice and become a master artist, you can take all the shortcuts you want.

Female Space Adventurer

Who said all cosmic swashbucklers had to be guys? This gal loves exploring new planets, seeking adventure and fortune among the stars, and taking on all types of deadly alien life forms. Many times, female characters seem to give young artists—especially young male artists—a hard time. Many young men become interested in drawing comics because of the cool, tough-guy superhero types and spend a lot of time in the macho groove of learning to draw square jaws and blocky upper-body muscles. And when they finally get around to drawing a pretty young woman, she comes out thick, rough, and, well, sort of mannish. It's a common problem.

At the most basic level, we use the exact same process as for drawing a male, but with different proportions. The shape of a woman's face is important. Use more of an upside-down triangular shape, with soft, curving corners rather than the hard, square-shaped face you draw for male characters. Females also have narrow shoulders and wide hips, the exact opposite of the wide shoulders and narrow hips of men.

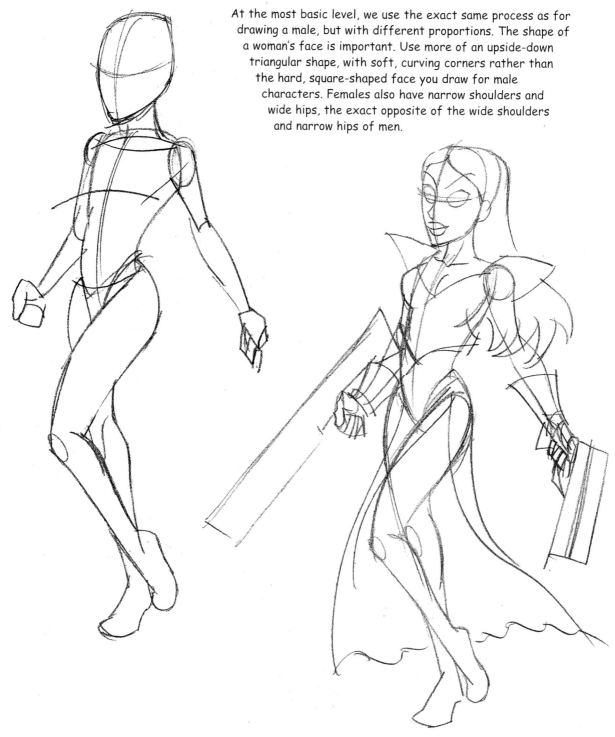

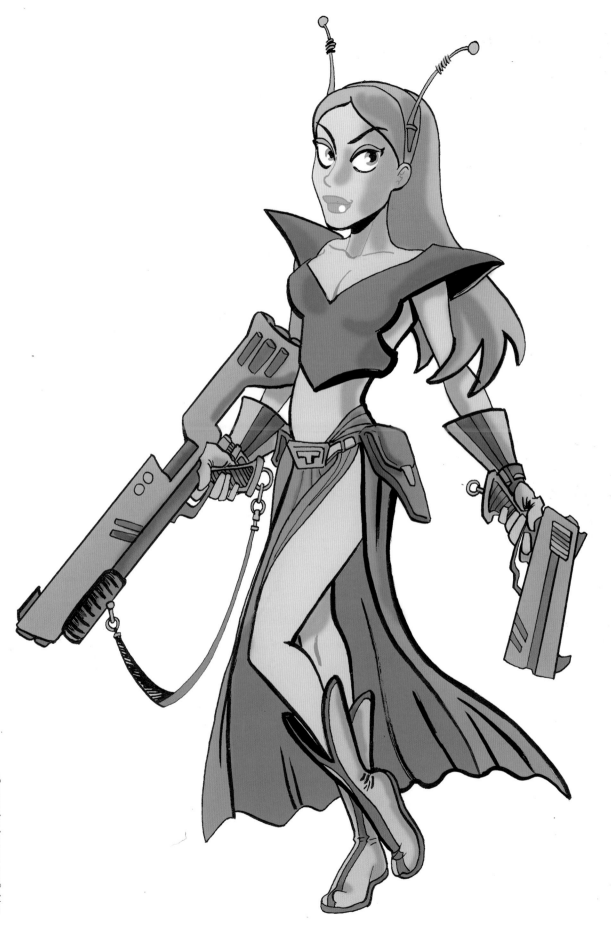

Female Cosmic Cop

She's the perfect partner for the Cosmic Cop (*see* next page), fighting on the side of the law and not taking any trash from anyone, human or alien. This is an exercise in drawing a more dynamic female figure, another example of how capturing the right attitude is half the battle of correctly depicting a character.

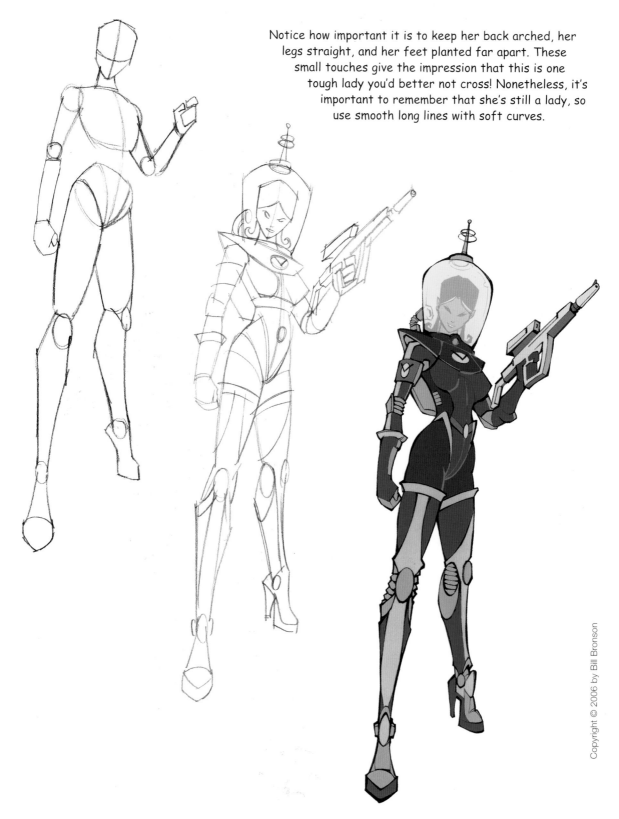

Notice how important it is to keep her back arched, her legs straight, and her feet planted far apart. These small touches give the impression that this is one tough lady you'd better not cross! Nonetheless, it's important to remember that she's still a lady, so use smooth long lines with soft curves.

Cosmic Cop

Killing aliens, as well as to serve and protect, are the sworn duties of the Cosmic Cop, who travels the galaxy in search of trouble, intervening where necessary, and preserving peace and justice on all planets.

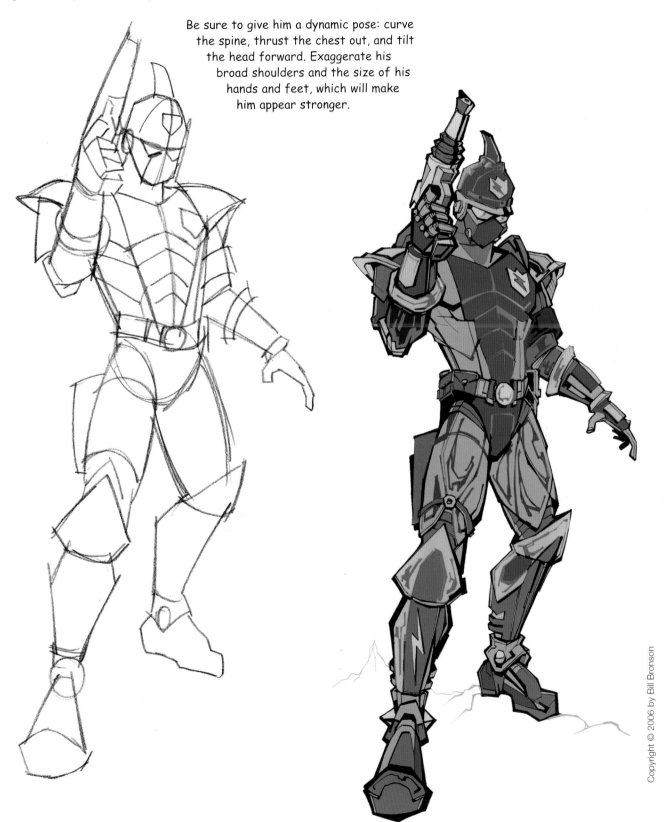

Be sure to give him a dynamic pose: curve the spine, thrust the chest out, and tilt the head forward. Exaggerate his broad shoulders and the size of his hands and feet, which will make him appear stronger.

Evil Space Tyrant

Ruling his section of the universe with an iron fist, the Evil Space Tyrant is interested in exploring other planets only to conquer, rule, and enslave the inhabitants. This character is a great example of complete exaggeration. His anatomy and proportions push the typical, dynamic comic book character to the extreme.

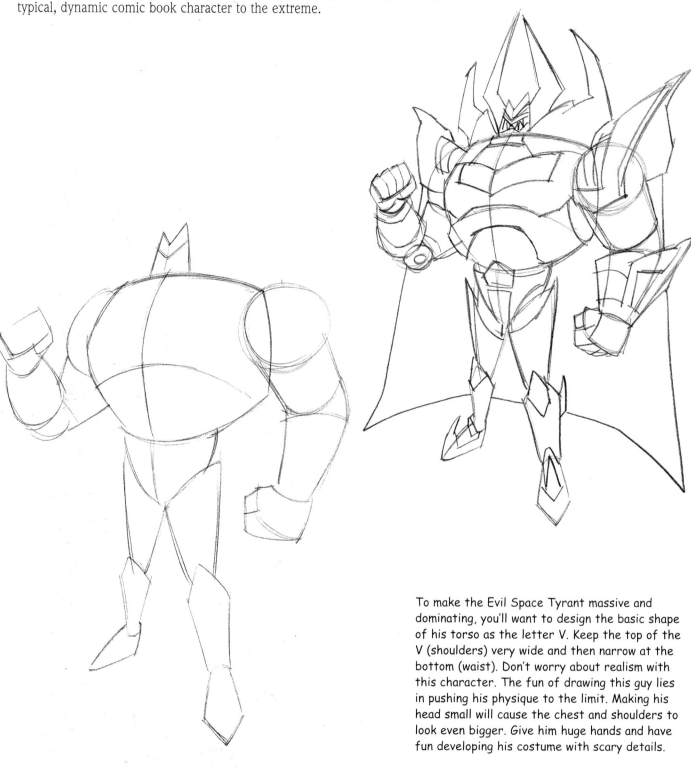

To make the Evil Space Tyrant massive and dominating, you'll want to design the basic shape of his torso as the letter V. Keep the top of the V (shoulders) very wide and then narrow at the bottom (waist). Don't worry about realism with this character. The fun of drawing this guy lies in pushing his physique to the limit. Making his head small will cause the chest and shoulders to look even bigger. Give him huge hands and have fun developing his costume with scary details.

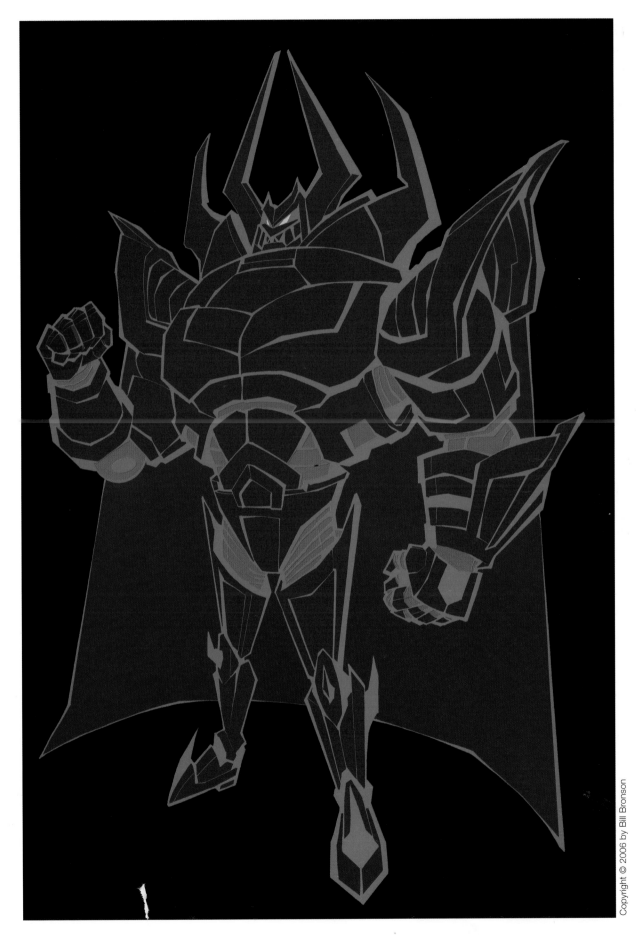

Copyright © 2006 by Bill Bronson

Xeno Hunter

This grim character makes it his business to find and exterminate dangerous alien life forms. Got a problem with cosmic monsters roaming around your territory? Was one of your loved ones captured, killed, or eaten by some hostile Martian? Just give this guy a call and he will hunt down and destroy those slimy aliens for you. Once again, this is an example of a basic human form inside a complex costume, so get the figure down first. The interesting helmet, the cool body armor, and all those weapons are not going to look right unless there is a basic human framework to build on.

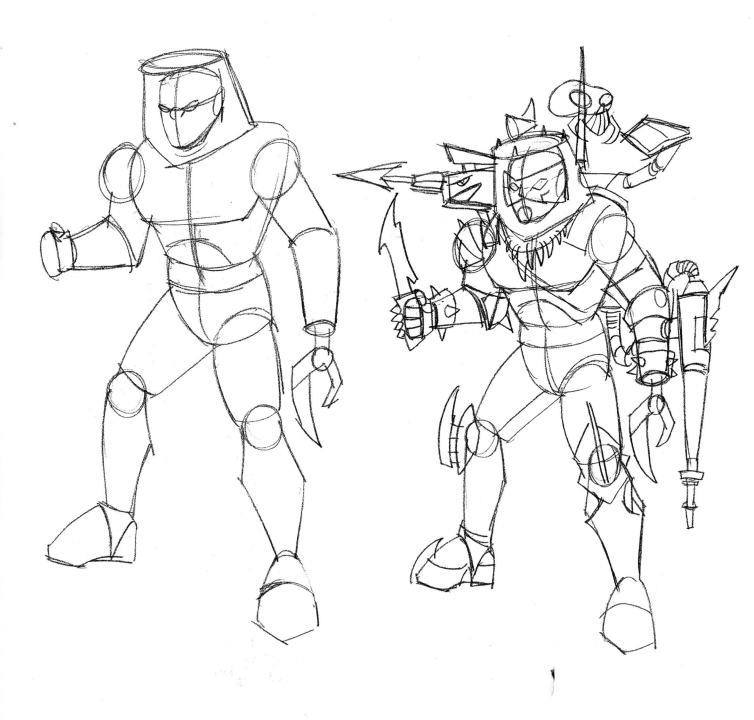

Construct the mechanical
claw-arm the same way
you would a normal arm,
but with a pincher-claw
instead of a hand.

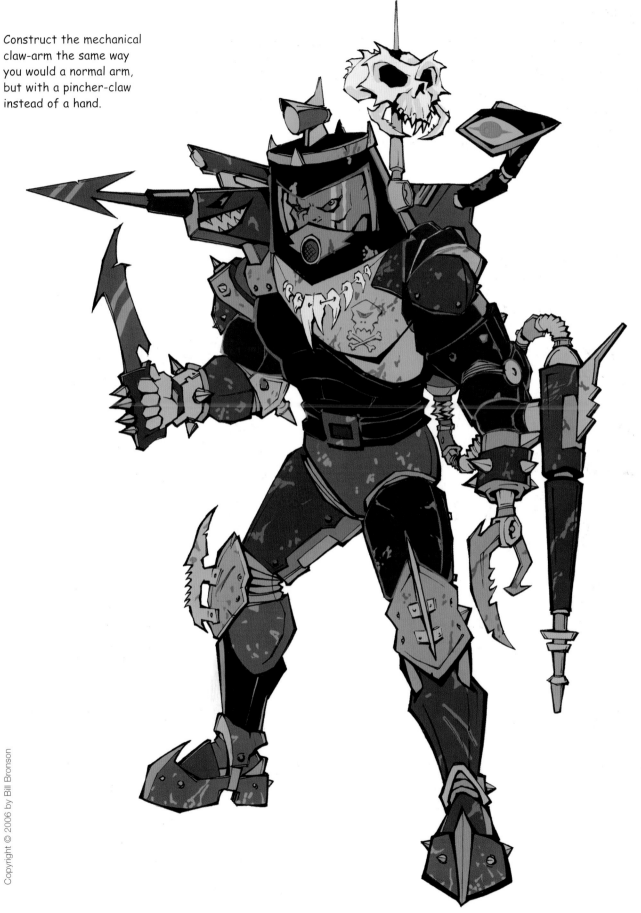

Good Space Queen

Wise, peaceful, serene, and motherly, the Good Space Queen keeps things safe and quiet in her galaxy. This character presents an interesting drawing challenge in that, on first sight, there does not seem to be any human anatomy to worry about. She appears to be just a pretty face with two hands hidden inside a bunch of robes, right? Wrong. If you've been reading the instructions to some of the other characters in this section, you will know that there *is* a human figure in there, no matter how obscured, and if you want this character to turn out right, you've got to take the time to map out the figure first.

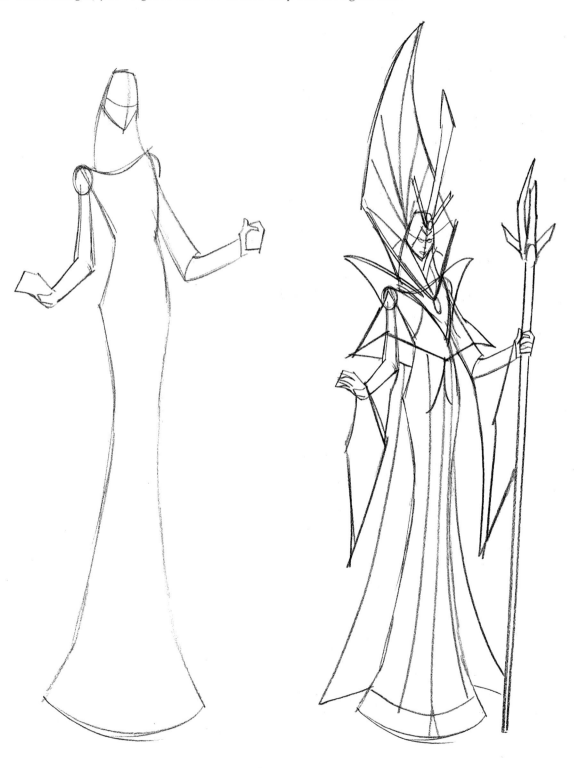

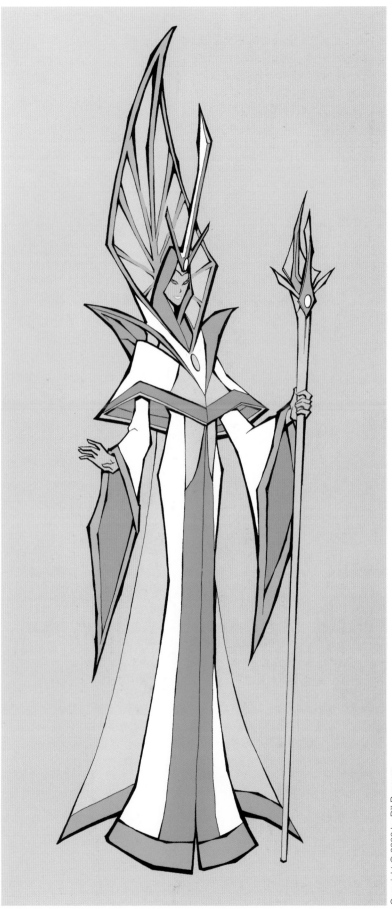

If you do not work out her proportions and delicate components, like the distance between her face and the floor or the careful relationship between her face and hands, they can—and will—be distorted, making your Good Space Queen awkward rather than angelic.

Space Princess

A somewhat more adventurous and mischievous intergalactic ruler than the Good Space Queen (*see* previous page), this Space Princess is not satisfied with simply living in her palace, making laws, and giving orders. This princess likes to get out and visit other kingdoms and planets. She is a little more sensual than the other females we have drawn so far. Her pose is more relaxed than that of the Female Cosmic Cop (*see* page 58).

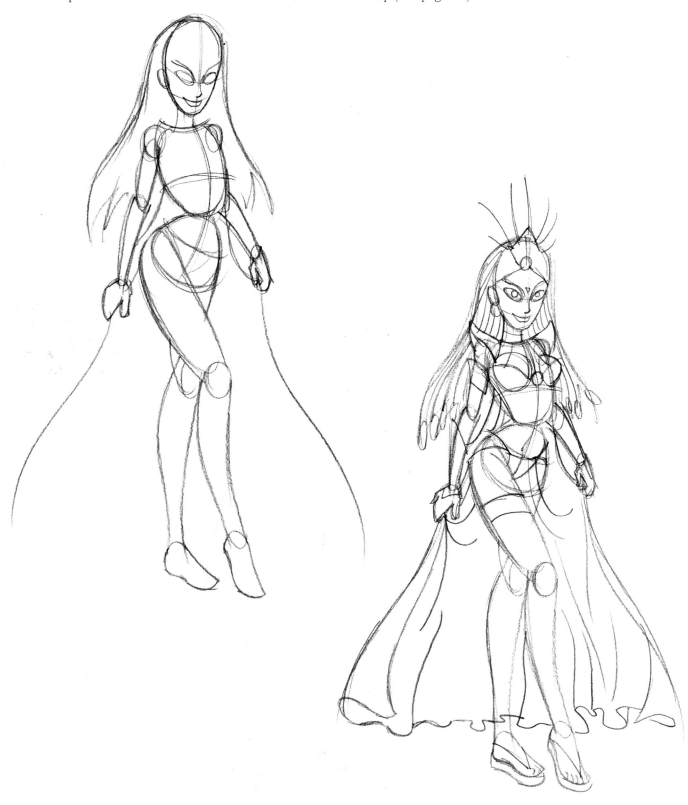

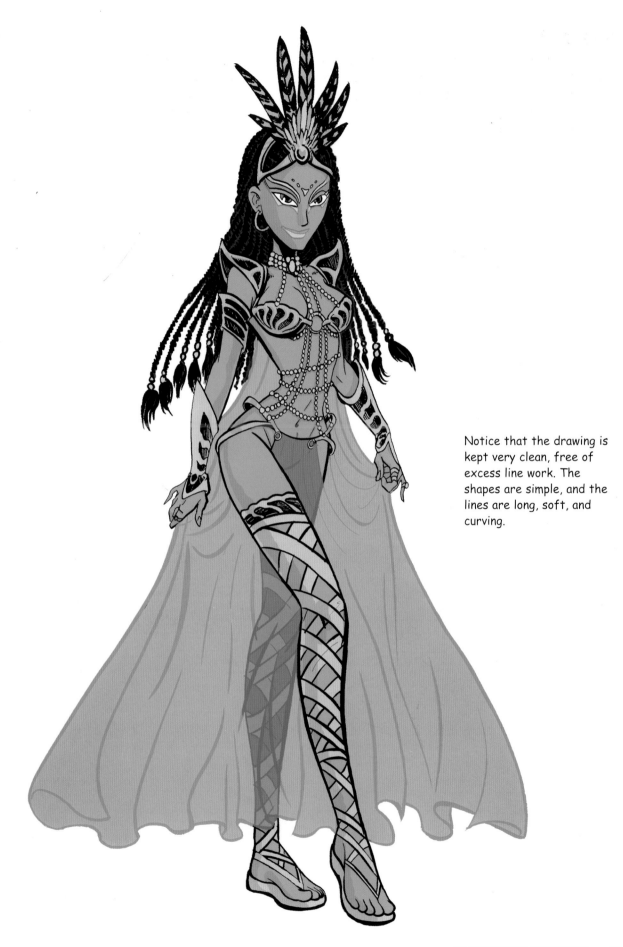

Notice that the drawing is kept very clean, free of excess line work. The shapes are simple, and the lines are long, soft, and curving.

Space Zombie

Strange gases in outer space can kill humans and cause their corpses to return to life as horrible, flesh-eating zombies. In this form, the undead space explorers may very well return to their home planets, spacecrafts, or space stations and attempt to eat their former companions. This zombie is a lot of fun to draw because he combines the challenge of human figure drawing with both sci-fi and horror aesthetics.

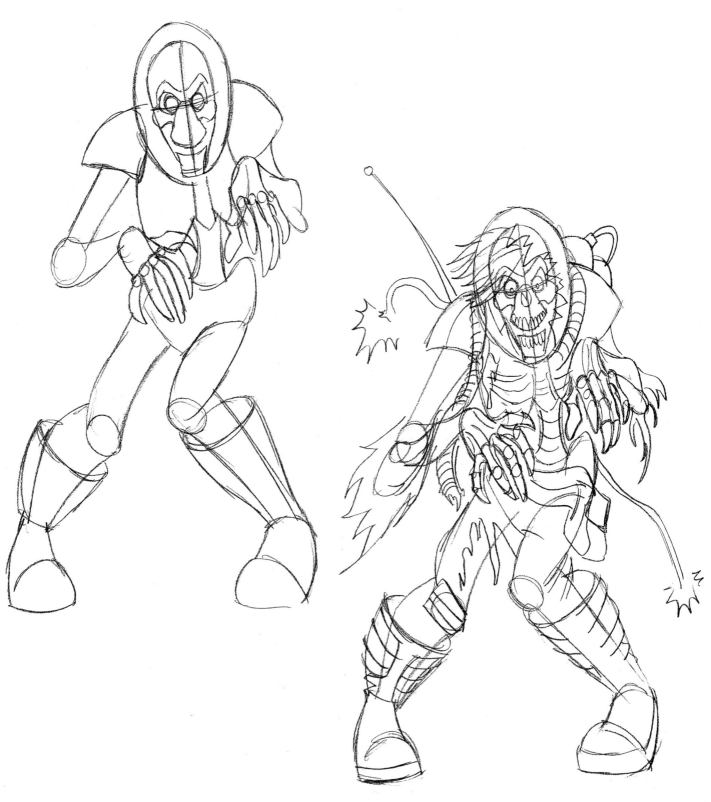

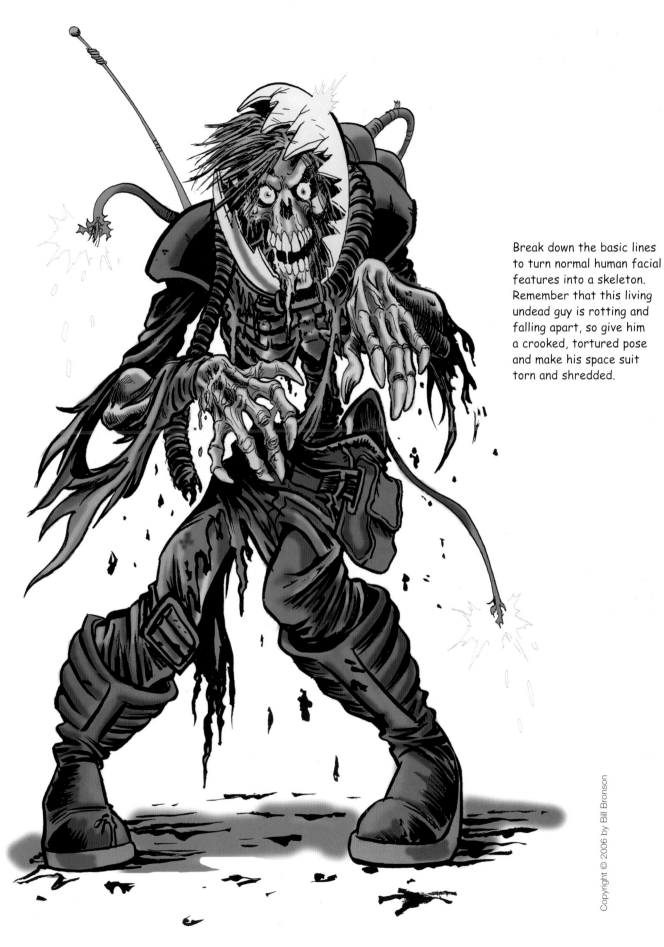

Break down the basic lines to turn normal human facial features into a skeleton. Remember that this living undead guy is rotting and falling apart, so give him a crooked, tortured pose and make his space suit torn and shredded.

DRAWING GREAT ROBOTS

Drawing robots is one of the cornerstones of sci-fi art, a discipline that combines the challenges of drawing futuristic technology with complete artistic freedom. As with aliens, robots come in all shapes and sizes. They can be tall, short, wiry, or rotund. They may appear stoic, threatening, or even lovable. Their mechanical bodies may be smooth and featureless or tangled in overlapping surface detail. Their anatomies may resemble humans, animals, insects, household appliances, war machines, or just about anything.

The concept of the robot is fascinating: a machine that was designed, constructed, and programmed to perform a specific function. If you think about it, a robot is really no different from a calculator, a refrigerator, or even a car, except that it can think for itself, and with thought, there is self-awareness, communication, contemplation, ideas, and a conscience.

Perhaps you are slightly resistant to drawing robots because you immediately think that it is time to drag out the old ruler and draw with perfectly straight lines. Well, I'm right there with you—I hate rulers! Drawing with them makes me feel restricted and pressured to draw everything exactly right; it makes me feel like drawing suddenly turned into a math class. As some of my fellow illustrators who created the robots in this book will later demonstrate, it doesn't have to be that way. You can always use a ruler in the last drawing stages, if you choose, but the comforting truth about drawing robots is that it is simply a matter of starting with a basic stick

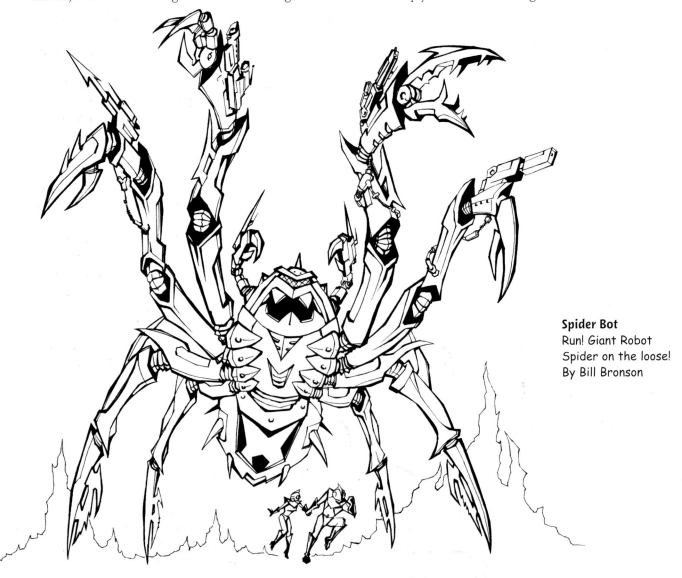

Spider Bot
Run! Giant Robot
Spider on the loose!
By Bill Bronson

figure composed of basic shapes, similar to drawing a human or alien. Don't think of your robot as a straight-edged machine, but rather as a character, with a mind and personality of his own. Get the character down on paper fast, sketching it into place using just your pencil and basic shapes, such as circles, cylinders, ovals, and squares. Tighten it up as you go, and then, at the end, when you feel you've successfully captured your robot, use the ruler, if you want, to make it look truly mechanical. You'll notice that although Bill Bronson's robots all have nice, straight edges, they have not lost any of their personality and do not appear stiff. (*Hint:* Bill saves the ruler for the very last step in his creative process.) Everything up until the last step is a loose, energetic pencil sketch.

It is most important to establish, right off the bat, the unique personality of your robot. Is it a friendly, childlike machine or a death-ray-zapping monster bot? Is it a slick, shiny new robot hot off the assembly line or a hundred-year-old clunker with dents, replaced parts, and scratches in the paint job? All these factors need to be worked out first, because they will determine the shapes with which you construct your robot. Depending on *who* your robot is, it may be better to give him or her the build of a superhero, a walking stick, a teddy bear, or a Sherman tank. As you go through this chapter, notice how each of the various robot characters directly reflects its unique personality and function. You can learn the basics of drawing robots by following the examples, but they are really just intended to be a basic starting guide. After you master the basic process, I hope you will take what you learn and start to design your own robot characters.

▲ Quad Bot
A powerful-looking, four-armed robot. By Jojo Aguilar

Dave White is a professional illustrator and video game artist. His many credits include art for such games as *Neverwinter Nights*, *Baldour's Gate: Dark Alliance 2*, *Mechwarrior 4*, and such books and comics as *Tales of the TMNT*, *Intergalactic Sushi*, and *Mecha Mania*. He's also pretty great at designing and drawing robots. In this brief interview, he explains some of his ideas, inspirations, and techniques.

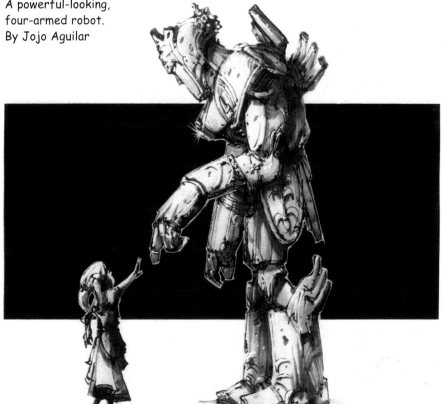

◀ Robot and Child
This fascinating little drawing was accomplished with a very simple technique, using gray markers over a light pencil sketch. By Jojo Aguilar

AN INTERVIEW WITH
DAVE WHITE

How would you describe your personal approach or style to drawing robots?

I have two styles, actually. One style is very organic and stems from my love of figure drawing. The second style is more rigid and based on typical industrial design–drawing ethics.

What has inspired the style you use when drawing robots? Any particular artists, writers, filmmakers, or movies?

Masami Obari was a big influence in the early nineteen nineties. I think Shoji Kawamori was more of an influence in the late nineties. I was also heavily influenced by the general style of *Mechwarrior 4* when I worked as the concept artist for several of the PC games.

How do you go about creating your robot illustrations? Can you take us through the process of how you get your ideas, design the character, and then execute the actual artwork?

I try to base my ideas on themes. If I don't already have a design in mind, then I will just doodle until I come up with some interesting shapes. I then take those shapes and see if I can form them into different mecha [mechanical] parts like a torso or leg. Once I have a part I like, I try to assign a feeing to that part within the entire mecha body. During this process I'm thinking about themes, like is this a flying mecha, a mecha made for underwater combat, a military mecha, etcetera. Themes let you focus your energy.

What would you say are some things an artist should avoid when drawing robots? In other words, what are the common mistakes that can potentially ruin a good robot illustration?

Don't be derivative. Try to make a mecha that is unique to you and really expresses your style. Also, don't draw on lined paper; get a real sketchbook so you can keep all of your drawings in one place. A sketchbook is one of the most important tools an artist can have.

Are there any tricks of the trade you'd like to impart to young artists who want to learn how to draw better robot characters?

Take a drafting class! You need to understand how perspective affects basic shapes. Understanding the basics of drafting will also help you draw better freehand circles and lines. I rarely have to use a ruler or circle template.

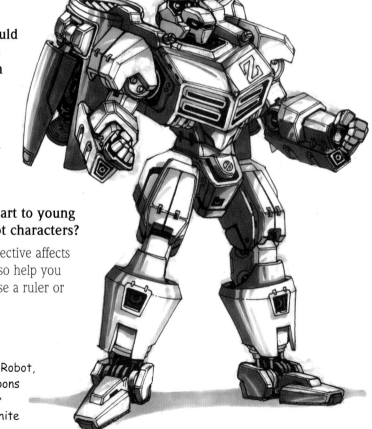

ZeroFinal
The ultimate Zero Robot, equipped with weapons and jet engines for flying. By David White

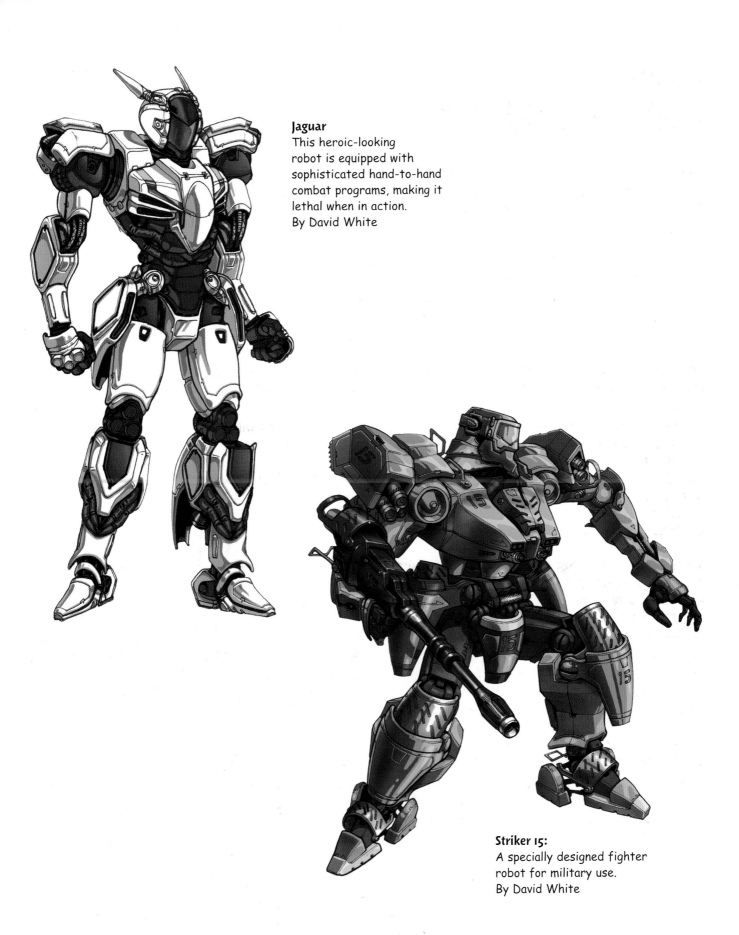

Jaguar
This heroic-looking
robot is equipped with
sophisticated hand-to-hand
combat programs, making it
lethal when in action.
By David White

Striker 15:
A specially designed fighter
robot for military use.
By David White

Concussion 2

Another dangerous-looking war robot armed with missiles. By David White

Concussion Mech

War machines of the future may look very different from those we know today. This Concussion Mech is heavily armed with an extensive arsenal of rockets and missiles. By David White

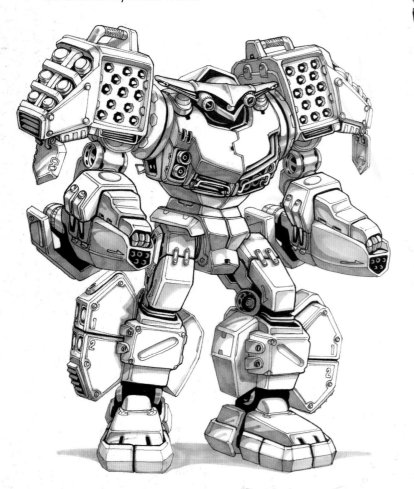

MechPoster

A powerful-looking robot flies through the cosmos. By David White

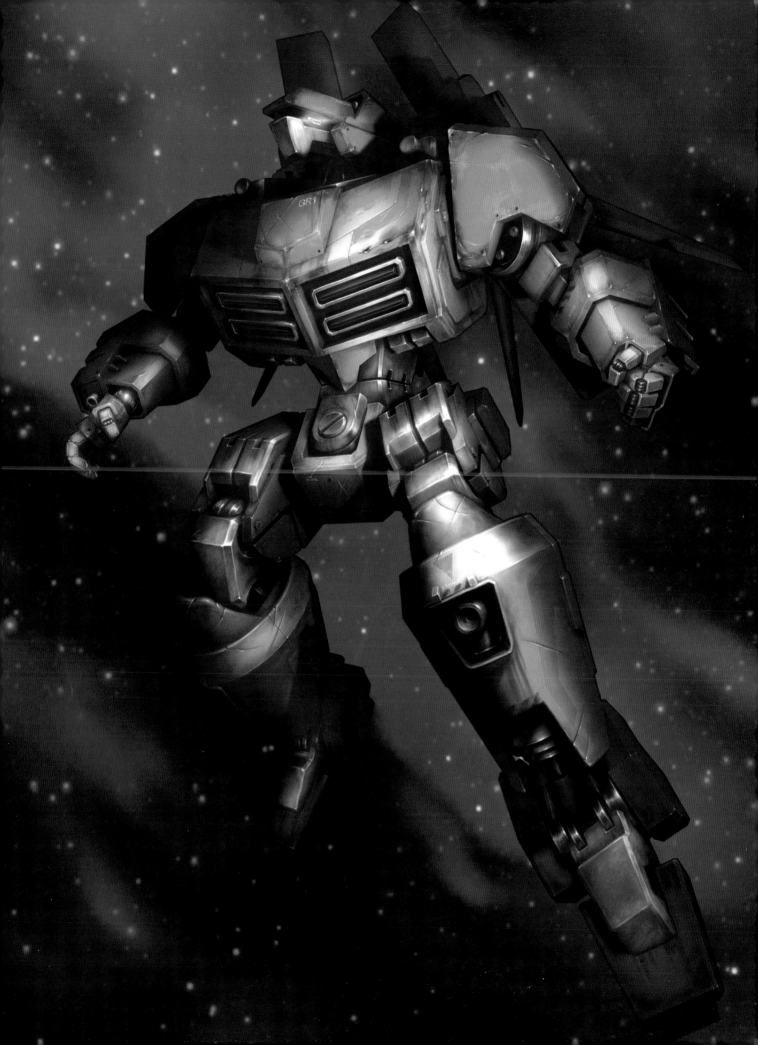

Zone Bot

Basic fighter robots built to be soldiers, guardians, or personal protectors, a group of Zone Bots makes an excellent security force for new space stations and settlements on alien worlds. It's also nice to have one of these guys with you when exploring unknown territories.

The Zone Bot's shape is basically human, with a head, torso, arms, and legs. You can lay out its basic framework as you would that of a human character, using a stick figure and shapes appropriate to its thin, squared robotic anatomy. This is an easy character to get you started.

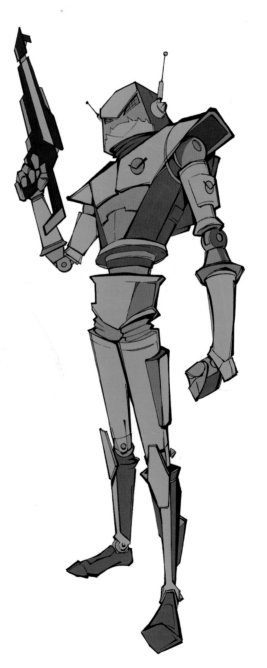

Think Bot 9-Million

Equipped with extremely sophisticated information processors and memory banks, the Think Bot 9-Million is a robotic genius. It can be trusted to run the computer systems of entire space stations, calculate the potential risks of space missions, and advise spaceship pilots. It is equally capable of completing tasks as simple as displaying interactive computer games to entertain and educate children.

Obviously, the basic shape that characterizes this robot is one big circle for the head. After that, it is a relatively simple matter of adding a small body and robotic arms. The fun part will be adding the tubes, wires, and antennae that decorate the head. Of course, you can give it an entirely different arrangement of surface details if you like.

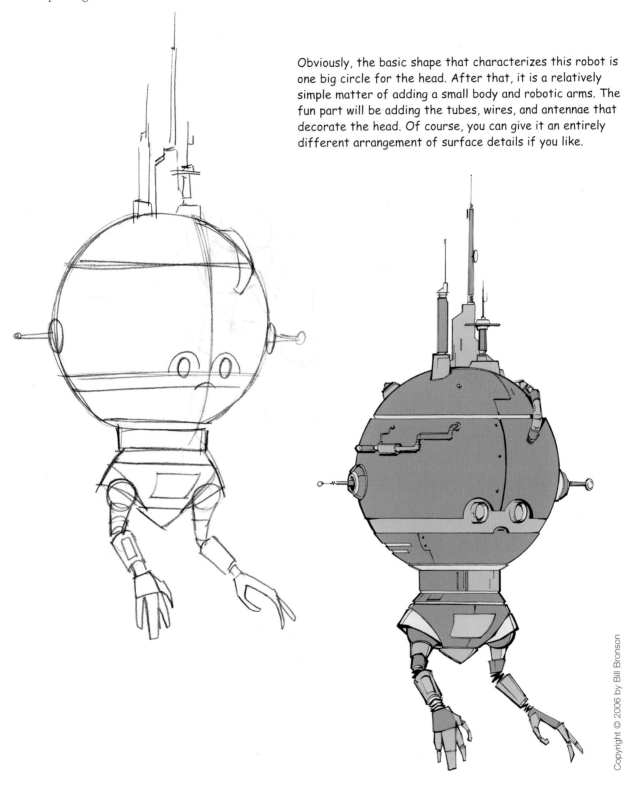

Gunner Bot

A walking battle tank with a mind of its own and an arsenal of laser cannons, rocket launchers, and other weapons, the Gunner Bot is covered with thick armor that can withstand almost all forms of enemy fire. A nearly indestructible, thinking war machine, this robot is one you definitely want on your side.

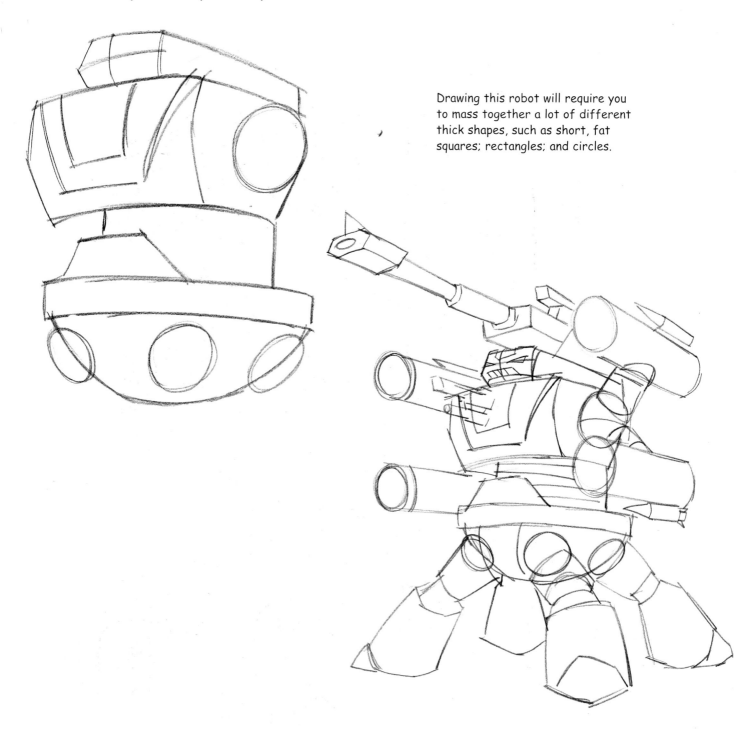

Drawing this robot will require you to mass together a lot of different thick shapes, such as short, fat squares; rectangles; and circles.

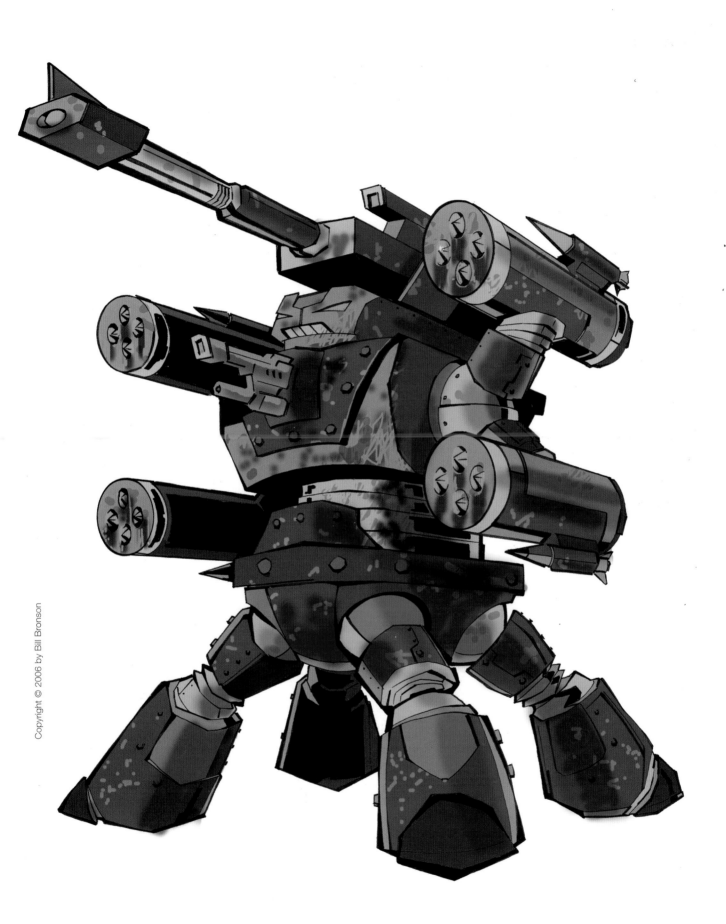

Ray Bot

Programmed with a friendly, good-humored personality and protective instincts, this robot was built primarily for companionship. It will get along with just about everybody, as long as they aren't threatening its master—in which case it can become quite dangerous.

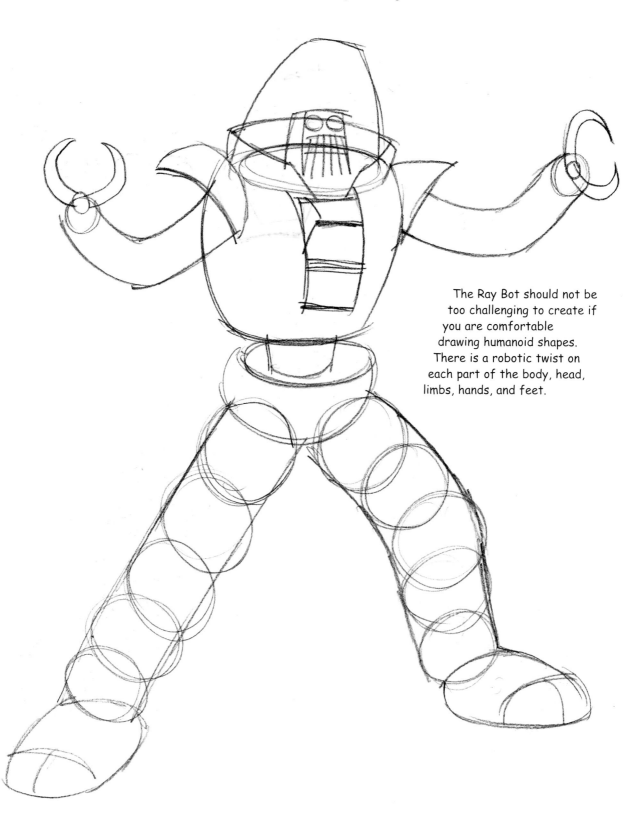

The Ray Bot should not be too challenging to create if you are comfortable drawing humanoid shapes. There is a robotic twist on each part of the body, head, limbs, hands, and feet.

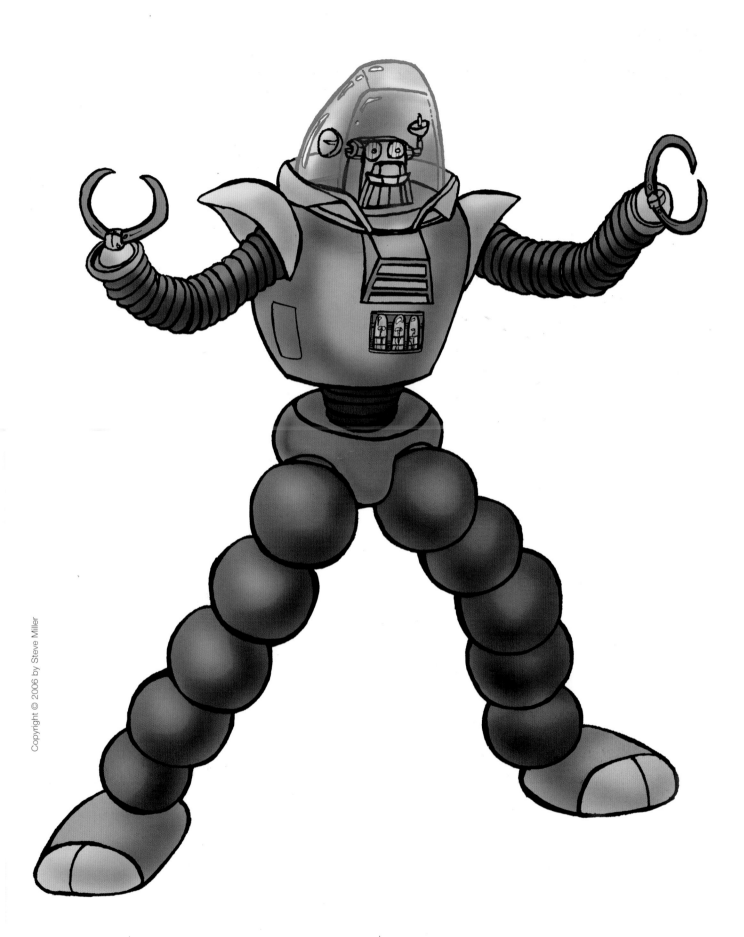

Good and Evil Cyborgs

More appropriately known as cybernetic organisms, cyborgs are both robotic and human. In some cases, cyborgs are humans who have had body parts, usually appendages or organs, replaced by mechanical parts due to injury or disease. Combining these two elements is often disastrous, resulting in either a human overpowered by machinery and driven mad or a mindless machine with a human sense of individuality and self-preservation.

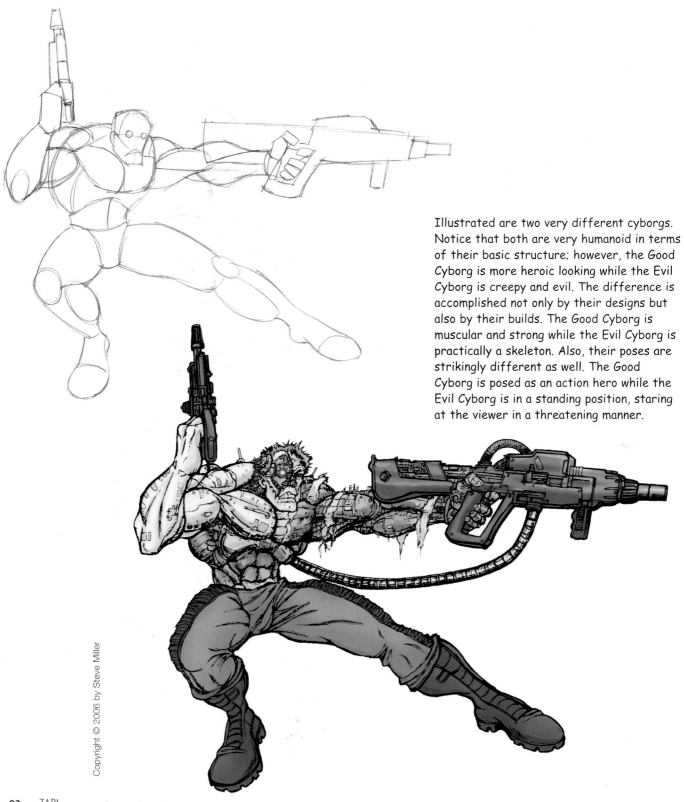

Illustrated are two very different cyborgs. Notice that both are very humanoid in terms of their basic structure; however, the Good Cyborg is more heroic looking while the Evil Cyborg is creepy and evil. The difference is accomplished not only by their designs but also by their builds. The Good Cyborg is muscular and strong while the Evil Cyborg is practically a skeleton. Also, their poses are strikingly different as well. The Good Cyborg is posed as an action hero while the Evil Cyborg is in a standing position, staring at the viewer in a threatening manner.

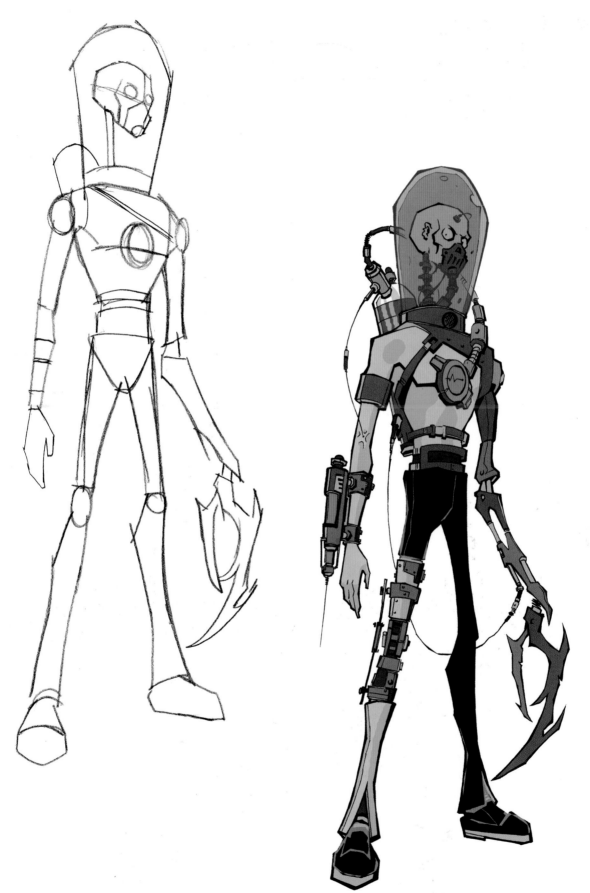

Skyborg

A dangerous battle robot that was specifically designed for aerial assault, the skyborg has jointed wings for flying at supersonic speeds. The Skyborg is known for suddenly sweeping down into enemy territory and laser-blasting its victims.

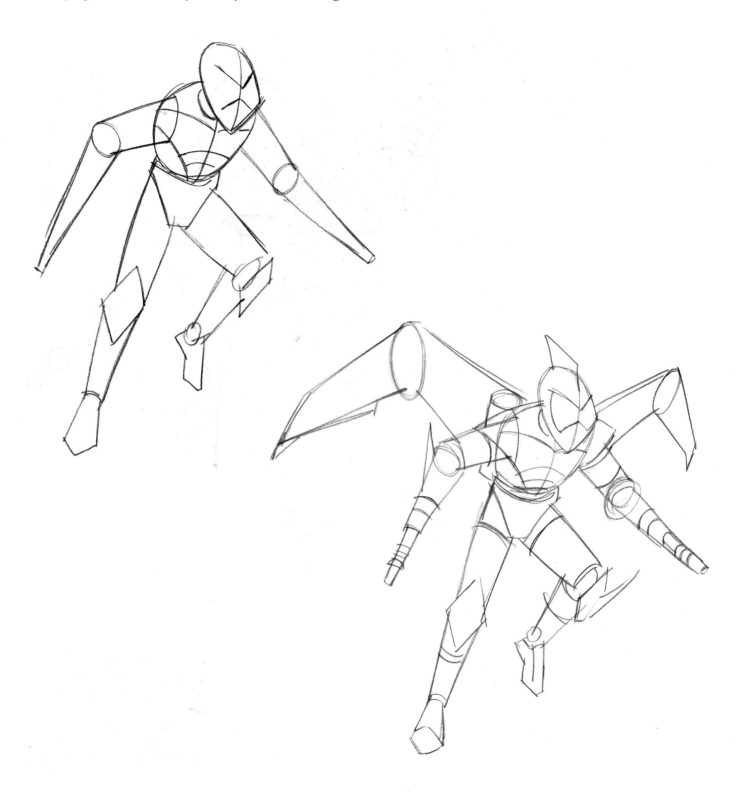

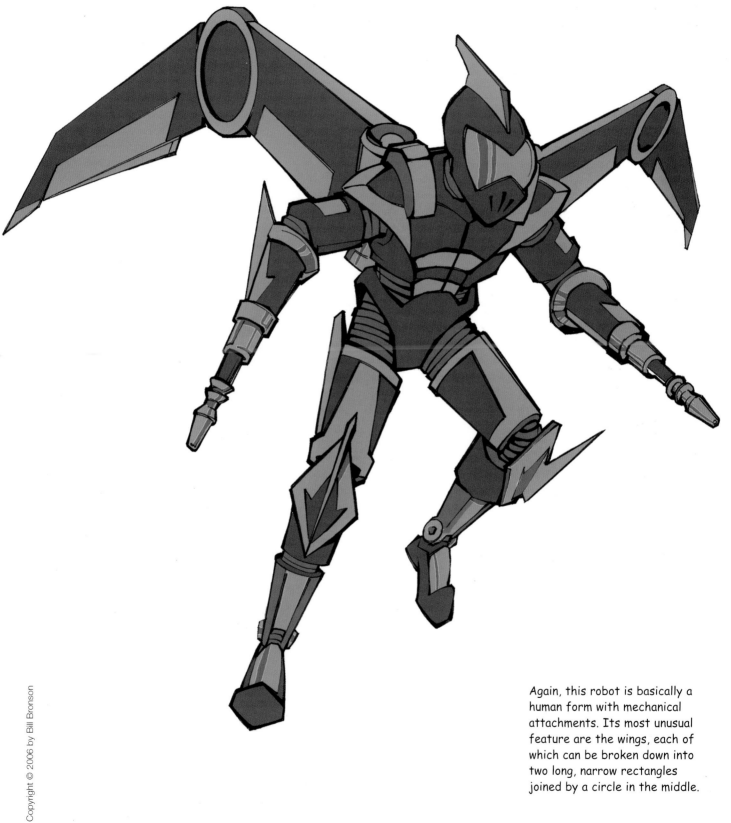

Again, this robot is basically a human form with mechanical attachments. Its most unusual feature are the wings, each of which can be broken down into two long, narrow rectangles joined by a circle in the middle.

Q-T Android

The Q-T Android was designed to be an ideal companion for the bored and lonely space explorer who must spend days, weeks, or months in a spacecraft while traveling throughout the galaxy on missions. Programmed with a cheerful, friendly personality and good sense of humor, the Q-T Android will entertain her human master with good conversation.

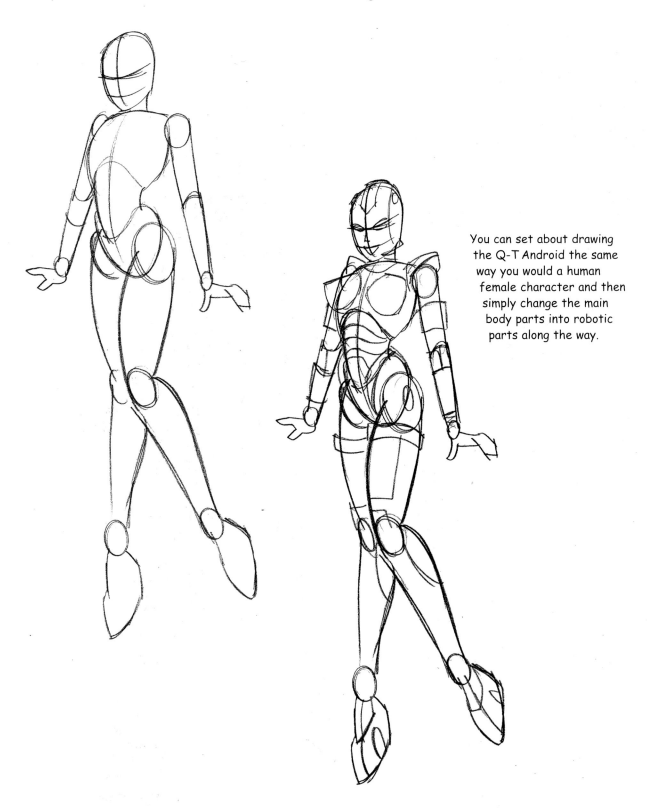

You can set about drawing the Q-T Android the same way you would a human female character and then simply change the main body parts into robotic parts along the way.

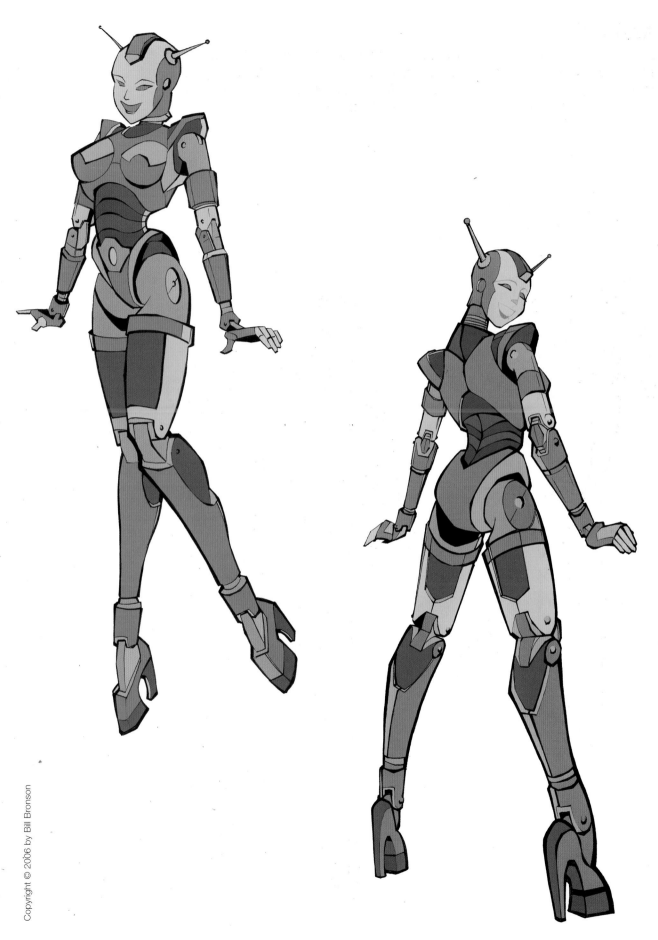

Servo Servant Series 6

Built and programmed to be either a butler for wealthy homes or a waiter in extravagant space station restaurants, the Servo Servant Series 6 aims to please.

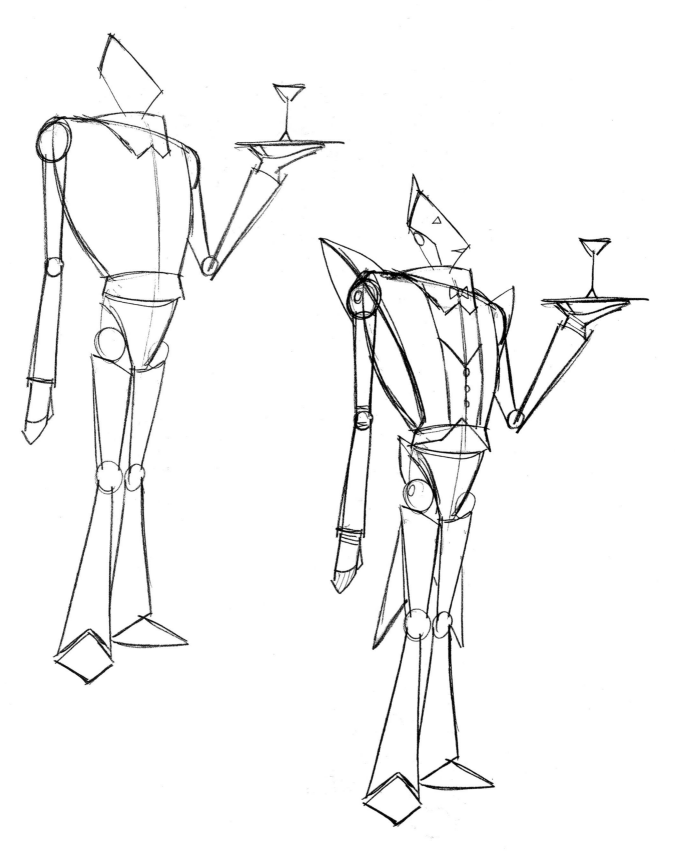

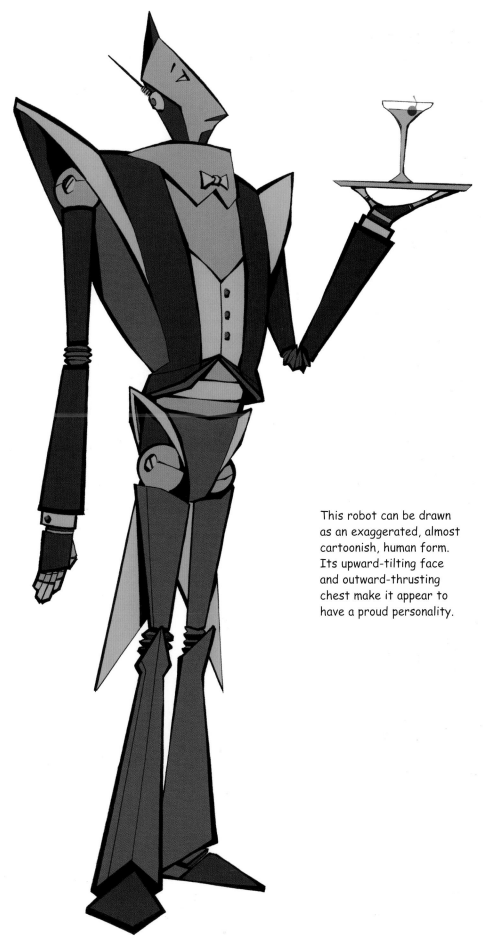

This robot can be drawn as an exaggerated, almost cartoonish, human form. Its upward-tilting face and outward-thrusting chest make it appear to have a proud personality.

Sonic Noise Droid 808

Originally intended to be an intelligent walking stereo system, the Sonic Noise Droid 808's programming failed terribly during its first party assignment, killing the guests with brain-shattering noise decibels. Becoming dangerously antisocial, it wanders the galaxy, using its powerful speakers to blast enemies with sonic force.

Keep this robot tall and angular and pay close attention to the lines in the face, which give it an angry expression.

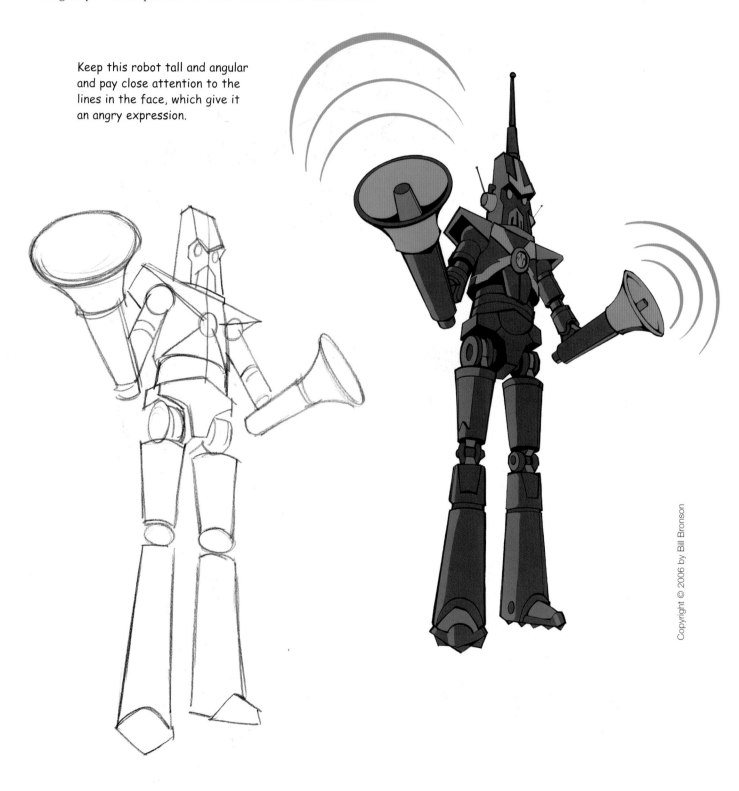

Zero Proto
A basic Zero Robot, designed for manual labor on military bases. It can also be equipped with weapons if needed, and has basic fighting programming.
By David White

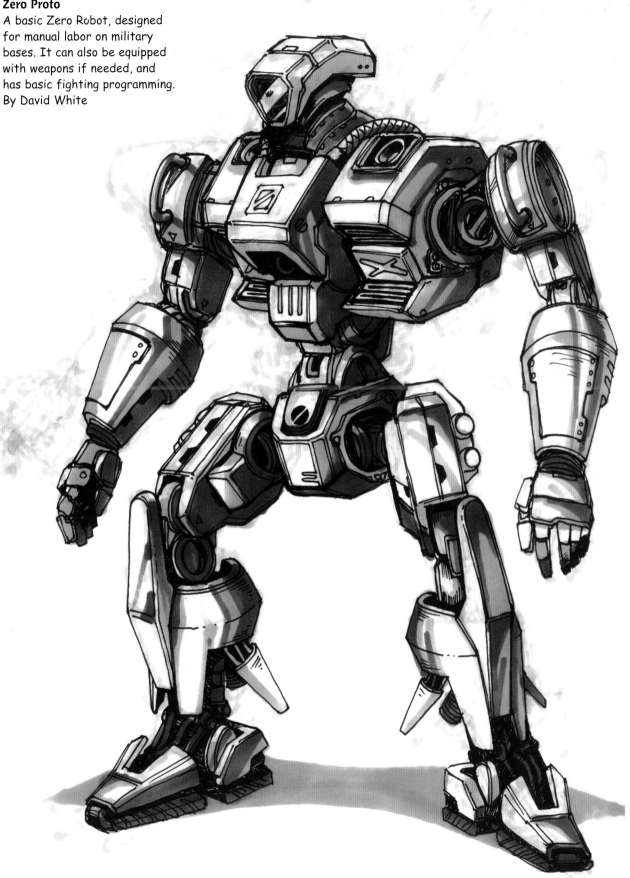

Cyber Sidekick

Small and lovable, the Cyber Sidekick was designed to be a playmate and companion for children confined to space stations and space vessels for long periods of time.

The body of the Cyber Sidekick is basically a short, squat cylinder. His arms and legs are also short, thick cylinders.

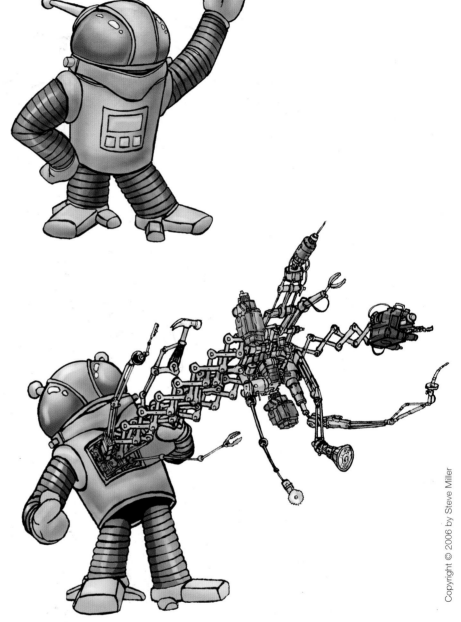

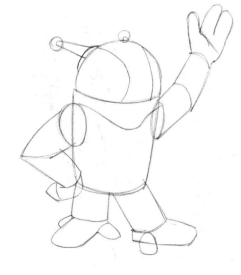

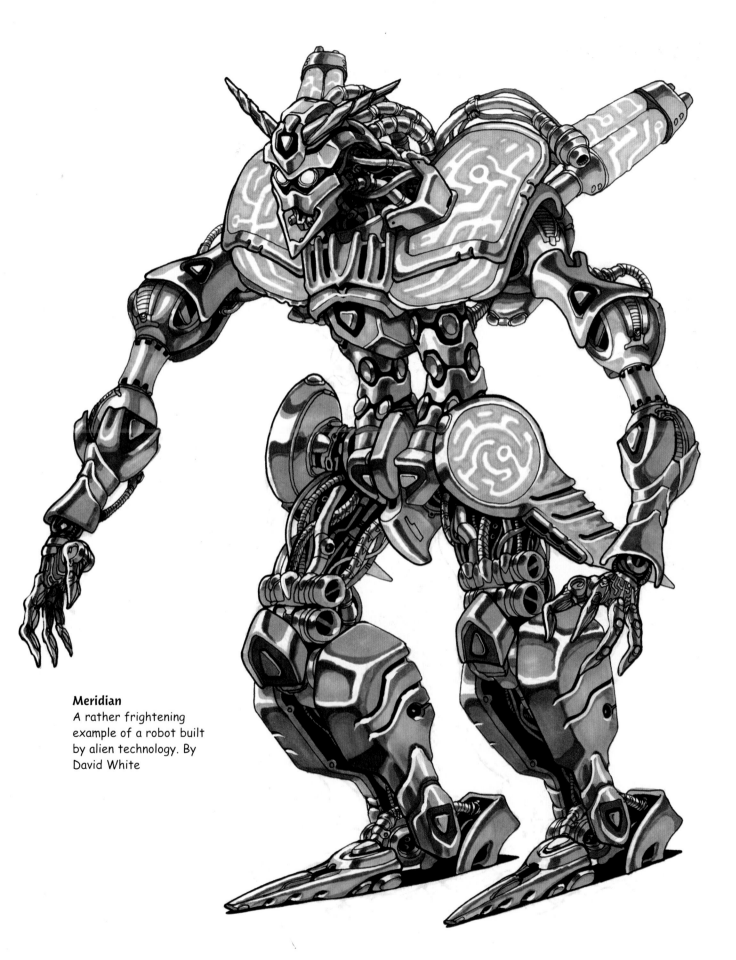

Meridian
A rather frightening
example of a robot built
by alien technology. By
David White

Assassin Bot

Designed specifically for sneaking up on targets and blasting them with deadly laser sniper fire, the Assassin Bot was built to silently scurry along the ground. Its wiry frame allows it to slip through tight spaces, and with clawed feet it can crawl up walls and hang upside down. It is built to seek out targets and take aim from every possible vantage point.

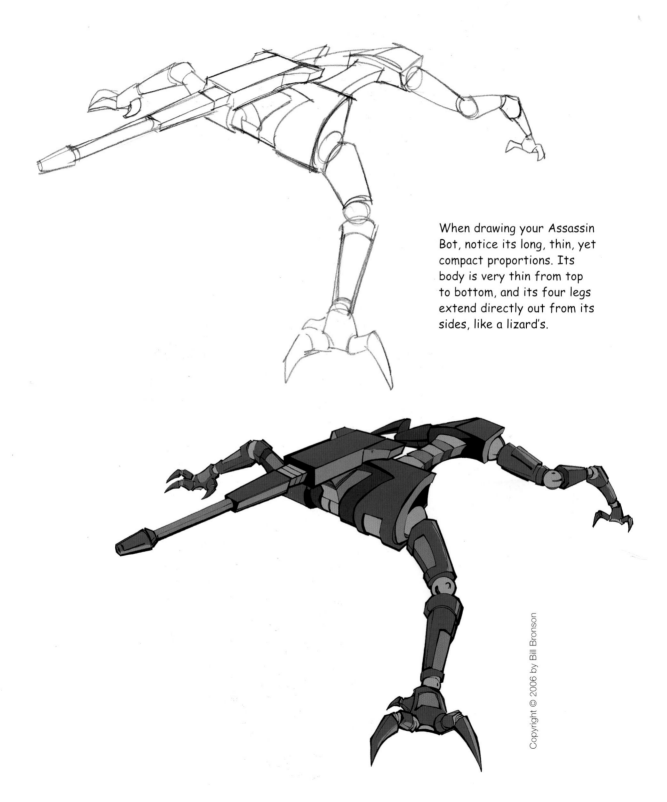

When drawing your Assassin Bot, notice its long, thin, yet compact proportions. Its body is very thin from top to bottom, and its four legs extend directly out from its sides, like a lizard's.

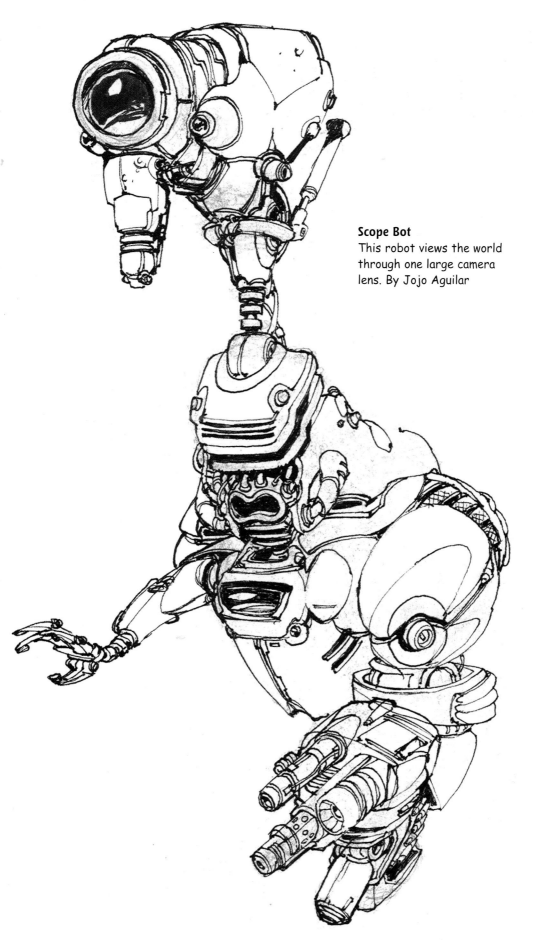

Scope Bot
This robot views the world through one large camera lens. By Jojo Aguilar

Medic Bot

Programmed with extensive files on the anatomies and biological systems of countless human and alien races, the Medic Bot is prepared to deal with almost any injury or illness. This doctor-surgeon never tires or needs a break and will not stop working until the patient is restored to health.

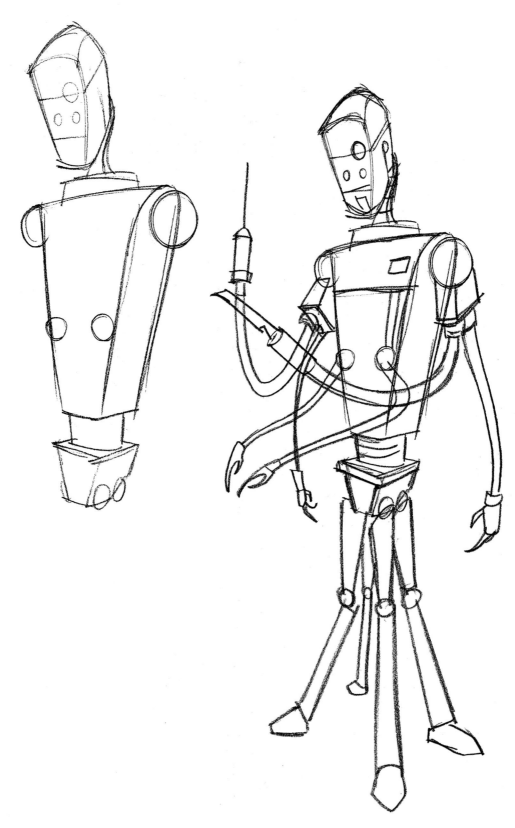

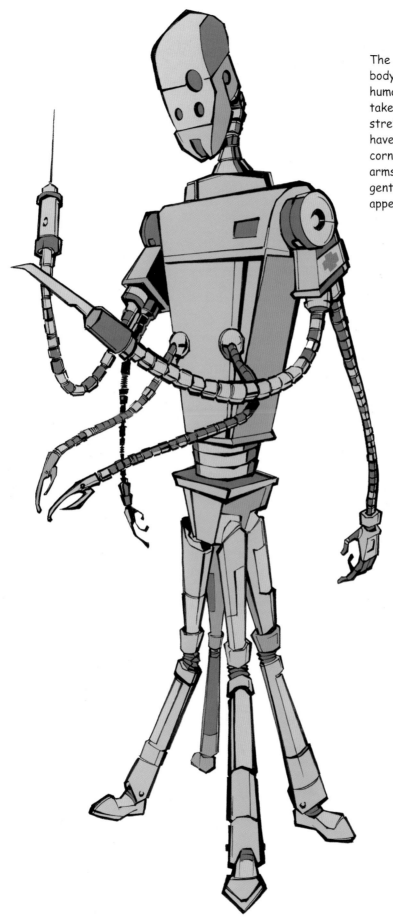

The Medic Bot's head and body may be relatively humanoid in appearance, but take note that both are stretched long and thin and have squared edges and corners, like a machine. Its arms are joined with supple, gently curving, and flexible appendages.

Gorilla Bot

Just a bad idea all around, the Gorilla Bot was built by an inventor who wanted to give a pet to his wife, an anthropologist. Unfortunately, the indestructible Gorilla Bot got loose. It wreaked destruction on several planets before finally being captured by intergalactic criminals, who outfitted it with weapons and reprogrammed it. This mechanical monster is a perfect example of how much fun it can be to design robots based on animals.

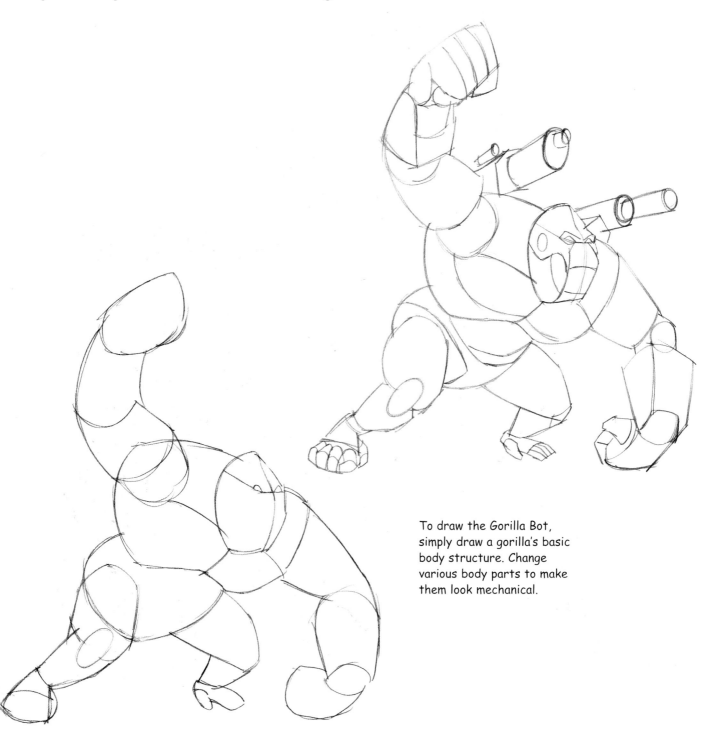

To draw the Gorilla Bot, simply draw a gorilla's basic body structure. Change various body parts to make them look mechanical.

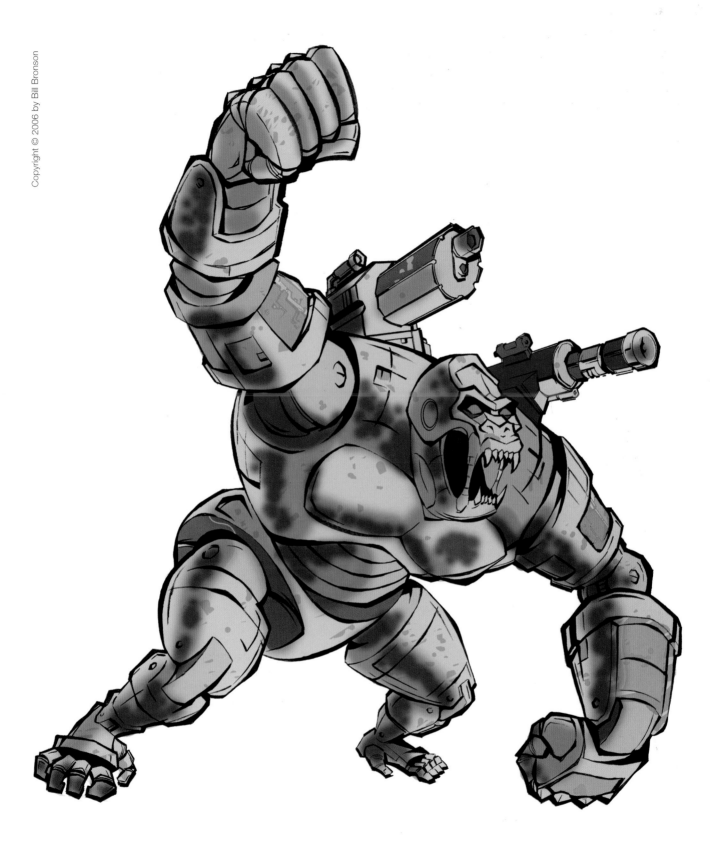

Torture Bot

The name says it all. Utilized by various legitimate and illegitimate organizations for the purpose of acquiring information from prisoners, Torture Bots are programmed to have an acute sensitivity to detecting the pain they cause their victims. This has led to the disturbing speculation that Torture Bots may actually derive pleasure from inflicting pain. Needless to say, this makes them incredibly dangerous automatons, especially if they escape from their employers. As with the Gunner Bot (*see* page 78), the Torture Bot is an exercise in taking many different, strange shapes and combining them to assemble a bizarre-looking machine.

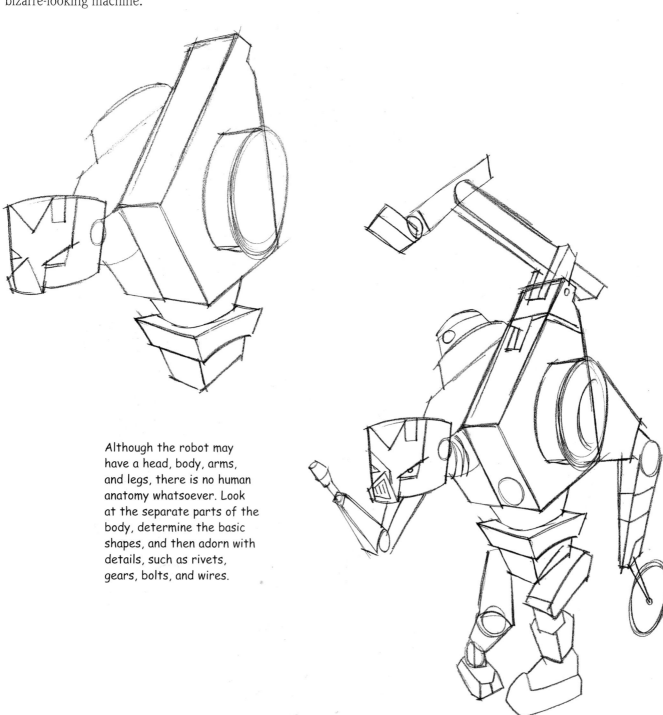

Although the robot may have a head, body, arms, and legs, there is no human anatomy whatsoever. Look at the separate parts of the body, determine the basic shapes, and then adorn with details, such as rivets, gears, bolts, and wires.

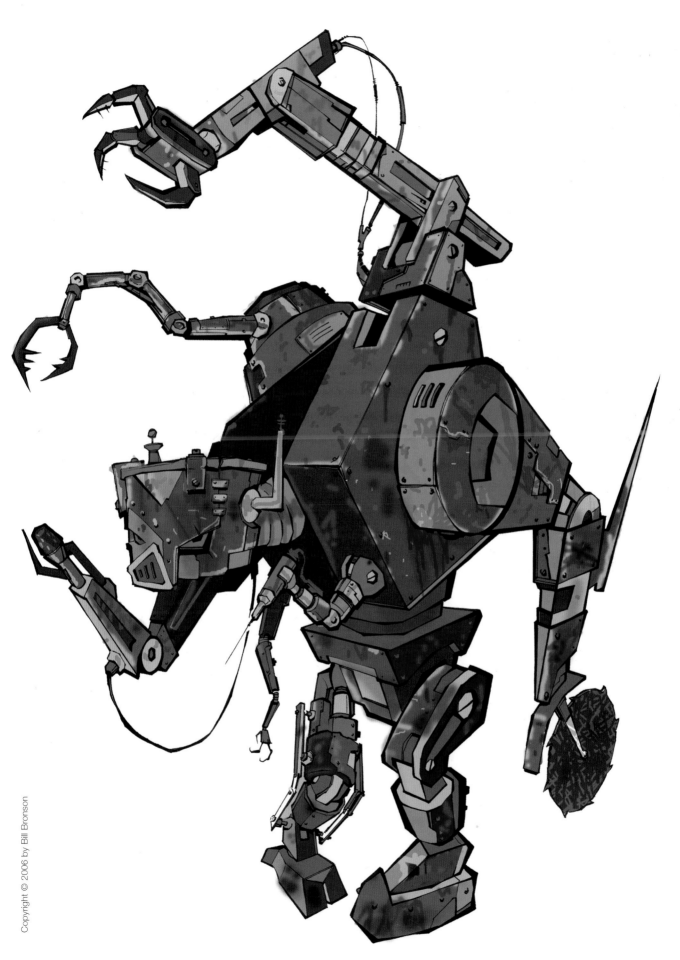

GETTING CREATIVE WITH ALIENS

In my opinion, inventing weird life forms from other planets is the most enjoyable aspect of drawing sci-fi comics. In this artistic playground, the sci-fi artist can truly let his or her imagination run wild. Aliens are fun to draw because they can look like anything—in fact, the weirder the better. After all, they are from other worlds, so there is no law stating that their biology should be consistent with what is found on Earth. You can make them big, small, cute, disgusting, humanoid, monstrous, or completely abstract. The only limit is the artist's imagination. In this section, I discuss three basic, yet different, approaches artists can take to drawing great aliens.

Ours is not the only world containing life. There are millions of different planets in the universe, and while some lie dormant and barren, others teem with as much diverse wildlife as our own. This chapter is about breaking away from the human figure—in some cases going to more of an extreme than others—to utilize pure imagination and experiment with body forms of all shapes, sizes, and appearances. For my money, inventing weird alien creatures from other planets is the most enjoyable aspect of drawing sci-fi. This is the playground where the sci-fi artist can truly let his or her imagination run wild. Aliens are fun to draw because they can literally look like anything. You can make them big, small, cute, disgusting, humanoid, monstrous, or completely abstract. The only limit is the artist's imagination. And the best part is, no matter how weird you make your aliens look, you can't go wrong. In fact, more often than not, the weirder, the better. In some ways, drawing the characters in this chapter will be freer, and thus easier because you are not confined to the rules of human or animal anatomy as we Earthlings know it. But in other ways, because it requires you to make solid, lifelike forms often out of ridiculous and imaginary shapes, it can be even more challenging.

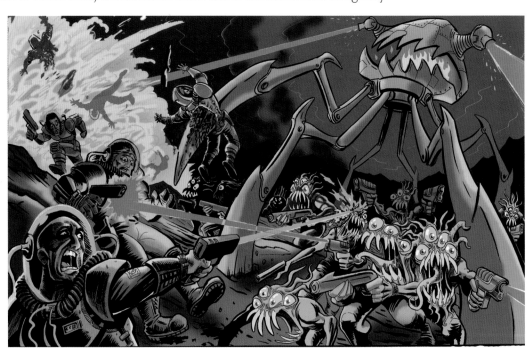

Alien Laser Battle
The natives of some alien planets may not respond favorably to visits from curious space explorers. By Bryan Baugh

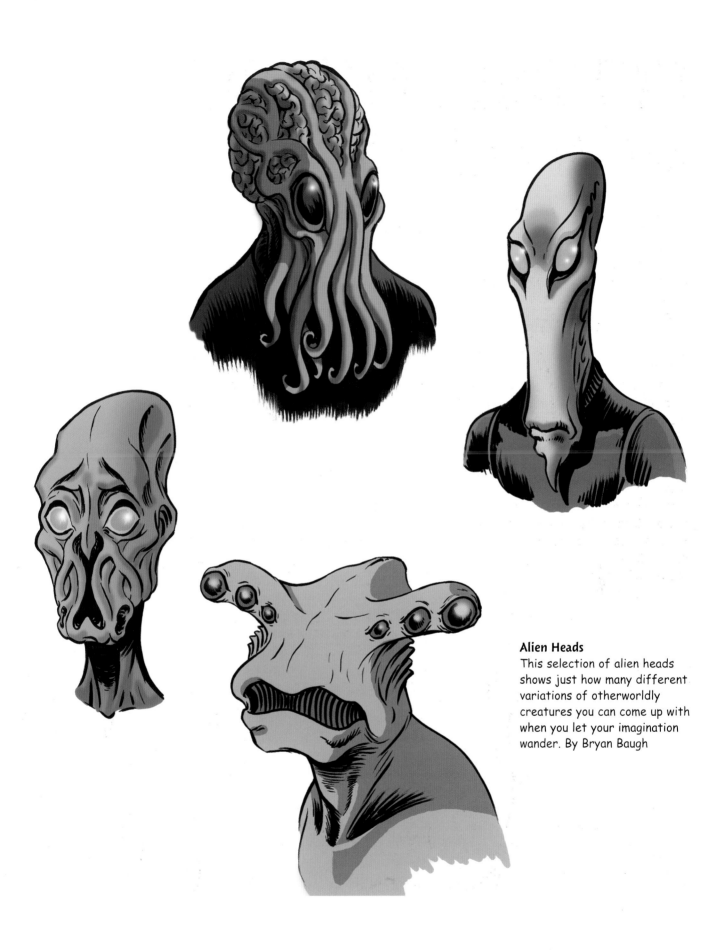

Alien Heads
This selection of alien heads shows just how many different variations of otherworldly creatures you can come up with when you let your imagination wander. By Bryan Baugh

THE NATURAL APPROACH

A popular view among many sci-fi artists is that a careful balance must be maintained between the imaginative and the natural in order to draw great aliens. According to this view, even if an alien creature is not supposed to resemble anything from the planet Earth, it still must look believable as a living, breathing creature that belongs to an animal kingdom on another planet in the universe.

A good strategy for achieving this effect is to incorporate features of real animals into your fantasy creations. Basing your aliens' physical features on those of creatures from the real world can result in convincing life forms that the viewer is willing to believe might truly exist.

For instance, say you decide to draw an alien with huge eyes filled with personality, but you do not want it to look like a cartoon. Start by asking yourself, "What kinds of animals here on Earth have interesting eyes?" You could study the eyes of owls, frogs, or fish from reference photos. There are also numerous species of lizards that have drastically different eyes from one another. You could also look at snails, which have bulbous eyes floating above their heads on tall, fleshy stalks. Or, if you are illustrating a story about an alien with big, scary hands like scissors that can snip its victims apart, a pair of lobster claws might work. Do a little research and find some photos of lobster claws. Study the shapes and find the subtle details that make the claws interesting, and add them to your snippy alien character.

Just as the animal kingdom offers countless options, so does the plant world. You could base the texture of an alien's skin on a lettuce leaf or create an alien with a mouth like a Venus flytrap. Look for patterns, colors, and textures in the natural world that correlate to your concept.

Simply put, the secret to mastering the natural approach is to study real animals and plant life and learn to draw them well. Developing a solid understanding of the anatomy of mammals, reptiles, birds, insects, and underwater creatures will tremendously help you with this technique. The more you learn about drawing real animals, the better you will be at borrowing their best parts and constructing new, alien creatures of your own.

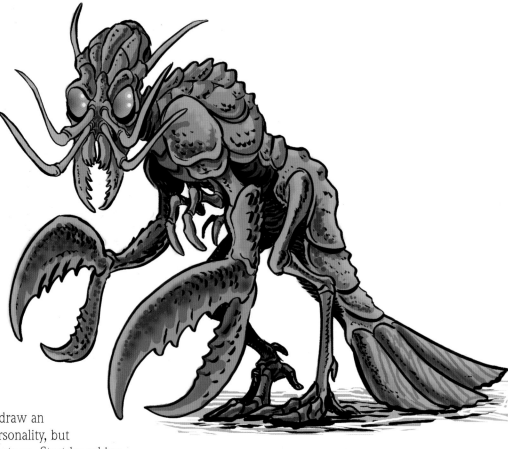

LobsterBug
Another weird example of alien life, this one apparently crustacean in nature. By Bryan Baugh

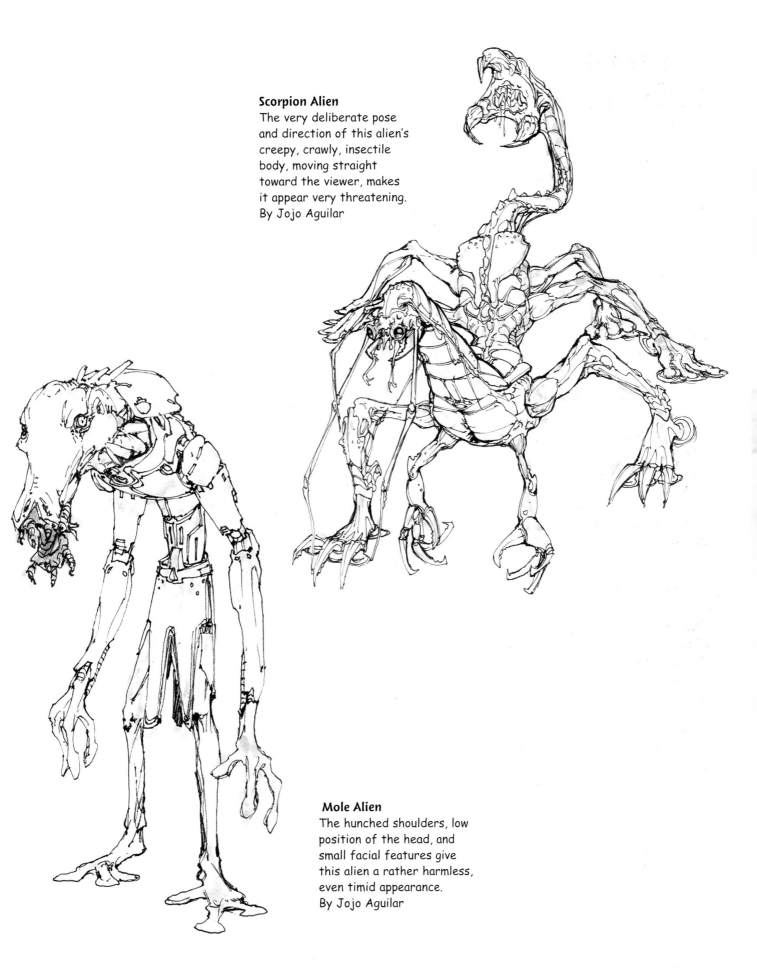

Scorpion Alien
The very deliberate pose and direction of this alien's creepy, crawly, insectile body, moving straight toward the viewer, makes it appear very threatening.
By Jojo Aguilar

Mole Alien
The hunched shoulders, low position of the head, and small facial features give this alien a rather harmless, even timid appearance.
By Jojo Aguilar

THE EMOTIONAL APPROACH

Sometimes an alien's physical appearance should be based on the emotion, or reaction, you would like to stir within the viewer rather than what will logistically make the most sense. This will especially be the case when depicting scary, evil aliens.

There have been many successful sci-fi novels, short stories, comics, and movies in which the aliens were horrible monsters who weren't the least bit interested in making friends with humans but rather wanted to destroy us and seize control of our tiny blue world. The authors and artists behind these works have frequently ignored the rules of biology for the sake of delivering the most hideous creatures imaginable—and for very good reason. The best strategy—and a high priority—in a sci-fi horror tale is introducing alien creatures that truly disturb the viewer at first sight. It might not be scientifically plausible for intelligent life forms from other planets to have huge, sharp fangs and daggerlike claws, but if you want to draw a scary alien and you find those features frightening, by all means go for it!

Beginning in the 1930s and continuing into the 1950s, a style of depicting aliens emerged in both movies and comic books that is still recognized today as the signature "look" of aliens from that era. Some folks simply refer to them as "50s-style aliens." Most sci-fi fans, however, call them BEMs, an acronym for "bug-eyed monsters." Check out any sci-fi comic book or film from the 1950s and you are bound to notice a few slobbering BEMs crawling out of docked spaceships.

Perhaps one of the best alien creatures in film history is the slimy, fanged monster from Ridley Scott's film *Alien*. Created by artist H.R. Giger, famous for his frightening, surrealistic paintings of hellish landscapes and biomechanoid (part flesh, part mechanical) bodies twisted into disturbingly suggestive poses, the alien in the film is a masterpiece of visual horror. This eight-foot-tall, glistening black nightmare looks like a hybrid of an insect and a human skeleton, and is a perfect example of an artist ignoring the concerns of scientific plausibility and going straight for the aesthetic jugular. The story called for a scary alien, and Giger delivered—and did he ever!—by giving his creature physical features that would trigger primal reactions of fear within the viewer. Many people are scared of bugs, so Giger gave the alien an insectile look. However, the face intentionally resembles a human skull, which is the universal symbol of death. It is rumored that Giger actually fitted a real human skull into the sculpture to ensure the alien's disturbing visage, making it one of the scariest monsters in film history.

Extreme Measures
Extreme problems require extreme solutions.
By Bryan Baugh

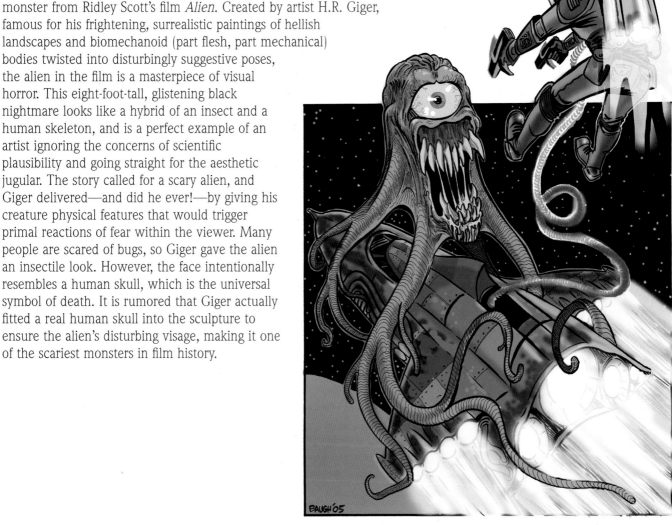

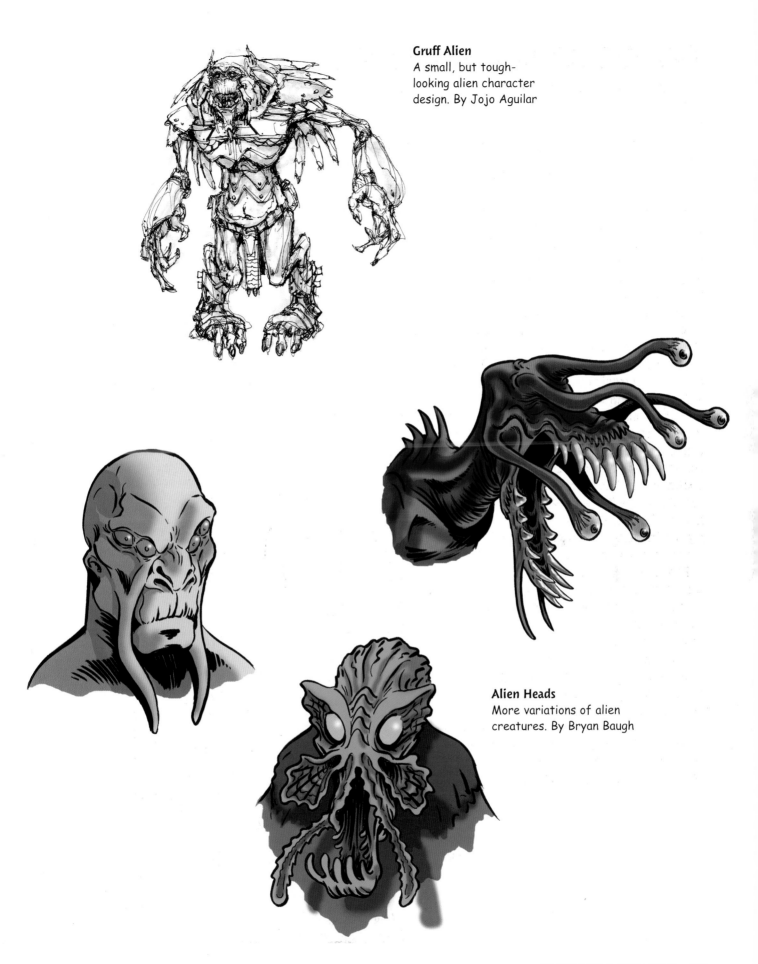

Gruff Alien
A small, but tough-looking alien character design. By Jojo Aguilar

Alien Heads
More variations of alien creatures. By Bryan Baugh

THE SURREAL APPROACH

The surreal approach to drawing alien life forms is perhaps the least popular approach, and yet, ironically, the one that tends to make the most logical sense. When taking the surreal approach, the artist designs aliens that do not resemble *anything* a viewer can relate to. Fans of this approach tend to be intellectual sci-fi aficionados who appreciate plots driven by hard scientific logic and speculation.

I know one professional comics artist who strongly believes that because aliens come from biological systems completely different from ours, aliens should not, therefore, be drawn to resemble any Earth animal, nor should they have discernible features such as eyes, mouths, limbs, or tails. Instead, my friend insists, alien creatures should appear in all sorts of bizarre shapes, from faceless, fleshy objects to floating spaghetti noodles. In fact, his aliens are about as otherworldly as you can get.

This is an interesting concept and has been used in a few comics to intriguing effect. However, let's face it: the visual impact lacks the punch of H.G. Wells' octopoid Martians from *War of the Worlds*, Giger's scary *Alien*, or even a good old-fashioned 1950s BEM, so I do not recommend it. In a visual medium of entertainment such as comics, the audience expects—as it should—to see something interesting. If you intend to design surrealistic aliens, you'd better have a very strong story; otherwise, you run the risk of looking very silly.

The three techniques described above are by no means mutually exclusive. In his great book *The Alien Life of Wayne Barlowe*, fantasy illustrator Wayne Barlowe masterfully blends the naturalistic approach with surrealism, creating images of mind-boggling creatures that at the same time seem anatomically plausible.

Alien Head Pencil Sketch
A screaming, horrific alien face, rendered in pencil.
By Jojo Aguilar

Alien Heads
By Bryan Baugh

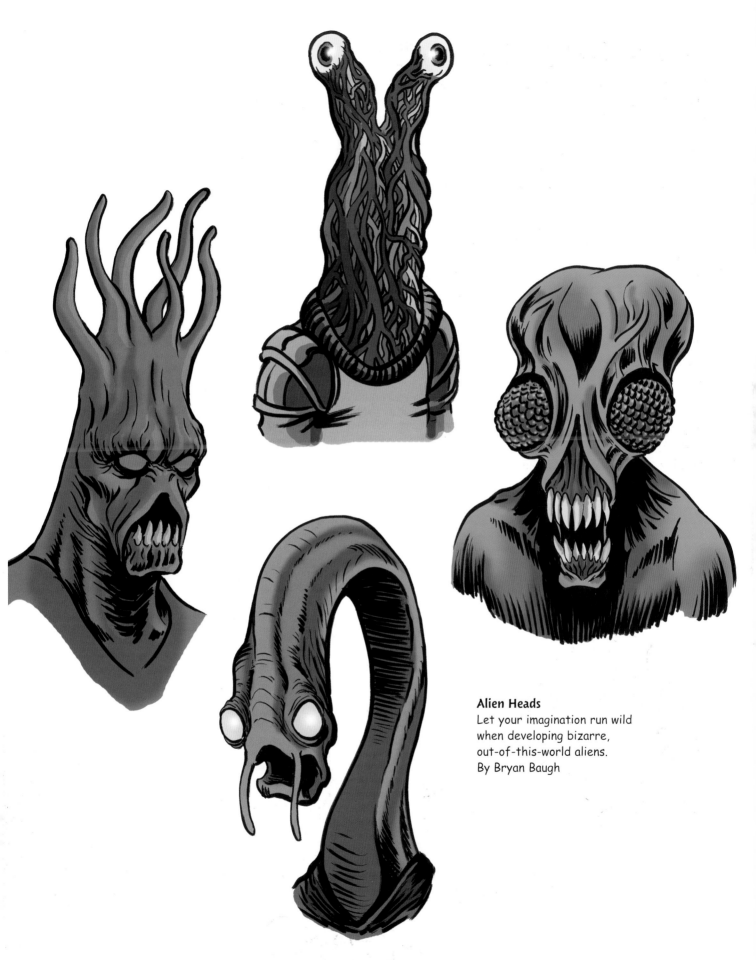

Alien Heads
Let your imagination run wild
when developing bizarre,
out-of-this-world aliens.
By Bryan Baugh

Angry Red Martian Monster

Many astronauts involved in missions to Mars have never been seen again because of these horrible red monsters. To draw this terrible character, break down the basic shapes and look at the construction.

You will realize that this character is really nothing more than a large head with one eye and a big mouth. Everything else—tangled tentacles, arms, and legs—grows from the sides of the head.

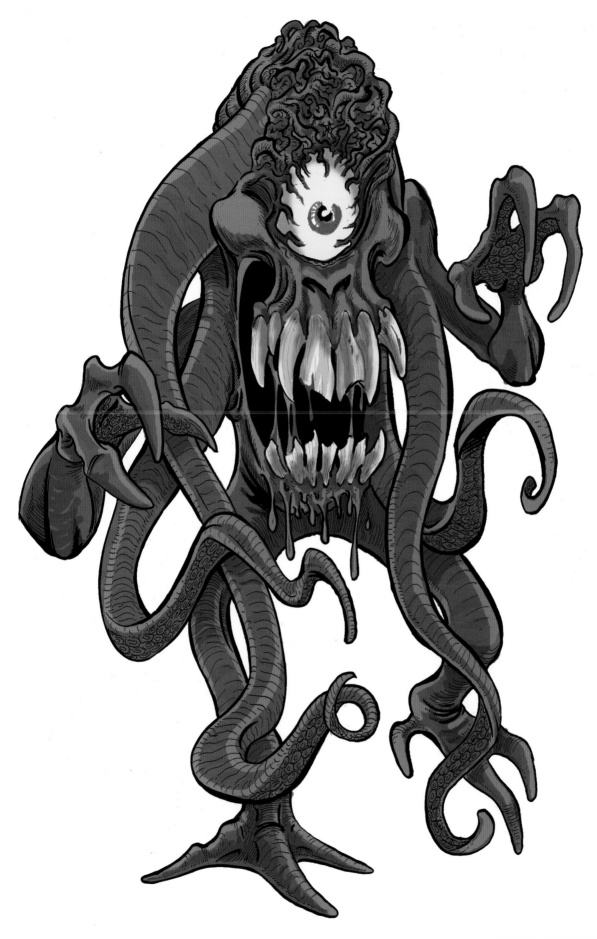

Venusian Bug Soldier

Insects are the dominant, intelligent life on Venus. These man-sized worker ants generally keep to themselves but will fiercely guard their complex civilization.

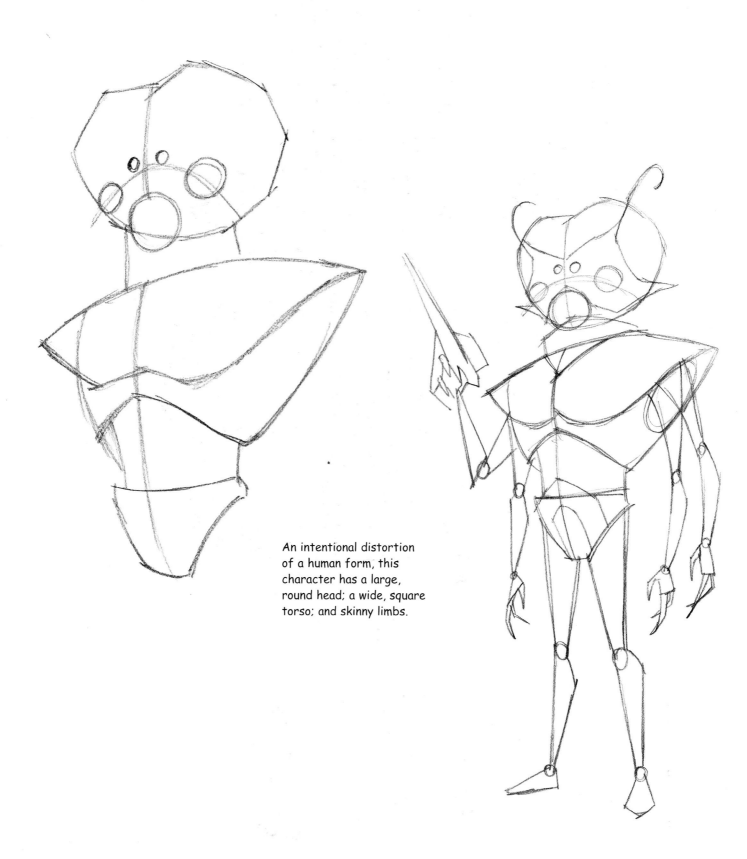

An intentional distortion of a human form, this character has a large, round head; a wide, square torso; and skinny limbs.

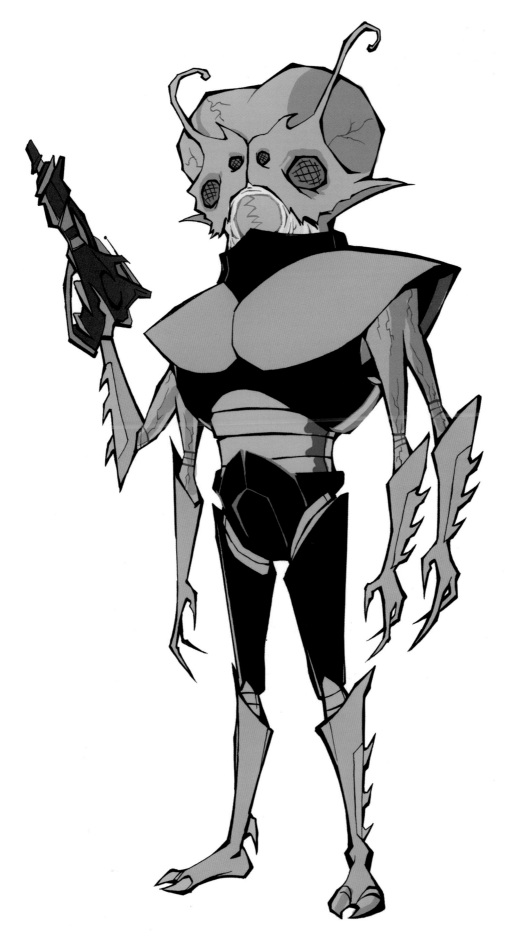

Moon Savage

Almost every moon is inhabited by these poor, dumb cave-dwelling primates. They eat moon bugs, odd plant matter that grows in the shadowy parts of craters, and sometimes visiting astronauts. Moon Savages might have developed more intelligence in a better environment. But it's hard to get smart when your world consists of nothing but moon rocks.

This character must have a strong yet stout look. Use basic shapes to build the muscle forms and then add a huge, swollen belly. Another important key to nailing the look of this creature is to set his head as low as possible on his shoulders and arch his back up, which will give him a slouching, deformed, primitive look.

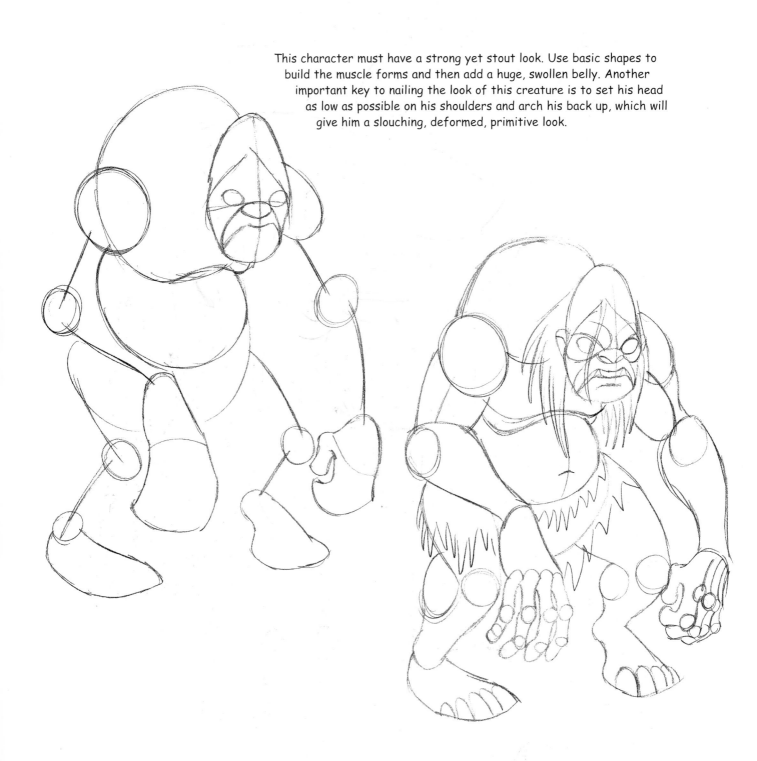

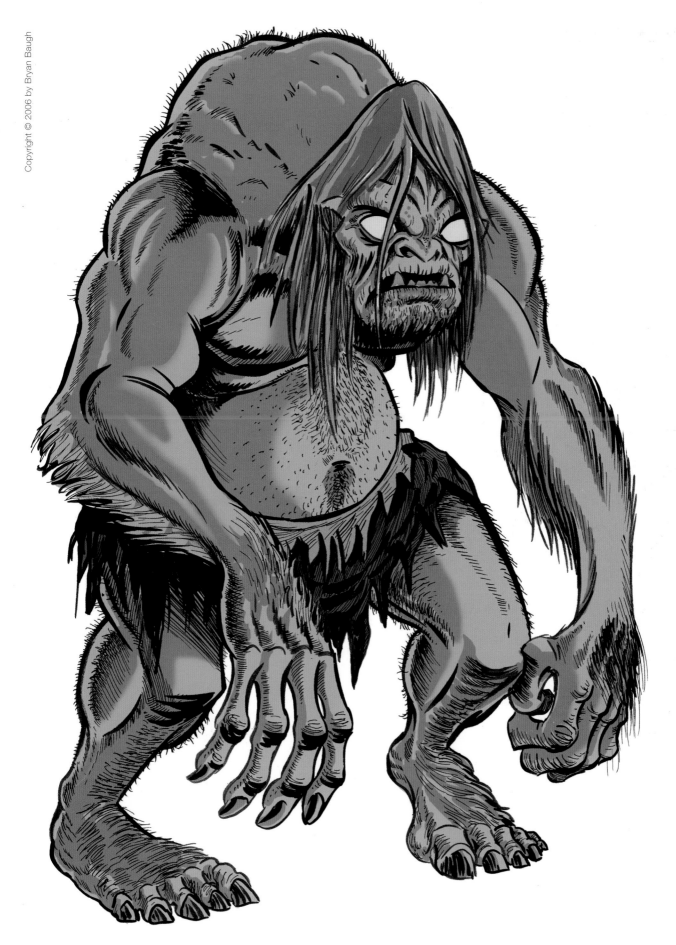

Super Slime Creature

Perhaps the most disgusting alien life forms in the universe, Super Slime Creatures float in space, attach themselves to spacecrafts, find a way inside, and proceed to eat whatever sentient life they encounter. This character is easy, as there are no proportions or anatomy to worry about. But slow down; don't jump right into it just yet. While there may not be too many rules or an exact formula to draw a Super Slime Creature, there is still at least one good trick I can recommend that will improve your end result. When you look at this creature, your first inclination may be to simply draw the blobby outline of the body and then add the eyes and mouth. I suggest, however, that you draw it the other way around. Start with the mouth, in order to center the creature. Then draw a bunch of eyeballs floating in the space around the mouth. Finally, draw the shape of the body around the mouth and eyes. The placement of the eyes will guide you, as well as give you a lot of fun ideas about how to bend, fold, and curve the shape of the disgusting, gelatinous body. Give it a try and see if it works. Be sure to detail the Super Slime Creature with lots of squiggly little veins.

As your very last step, show it to a friend and make them say, "Yuck!"

King Reptile

There are many different races of intelligent lizards throughout the galaxy, but they all look up to the highly evolved King Reptile. The trickiest challenges about drawing this character are the textured scale patterns and the cape. For those up to the task, let me assure you, drawing the Reptile King is not as tough as it looks. You just have to know how to approach it. Ignore the scales and cape for now and start to get the basic form of the body down. Use a simple stick figure and appropriate shapes to indicate the head, arms, legs, and muscle groups. Then add the important details—his eyes, teeth, and claws, and the ridge along the top of his head.

Once you have your King Reptile in basic form, start to draw his cape. Capes are tricky, but they can be fun once you get the hang of drawing them. Pay attention to the direction of the lines. Notice how they curve around the shapes of the neck and shoulders. This is very important. Learning how to make your lines wrap around the shape of your character's body is the difference between drawing realistic cloth and drawing flat, boring, lifeless capes that look like they are made out of paper. Use long, smooth lines so that the cape appears to flow.

Lastly, start drawing the scales. Look at them closely and you'll see they are nothing more than a bunch of little triangles, diamonds, and squares, which most artists can handle by the first grade. Draw these simple shapes all over his body. This might sound like a time-consuming, tedious chore, but don't be such a lazybones. Once you start, it will be fun figuring out at what angle to draw them in order to best describe the curvature of King Reptile's body. Plus, when you're done, people will look at your drawing and say, "Wow! Look at all that detail!"

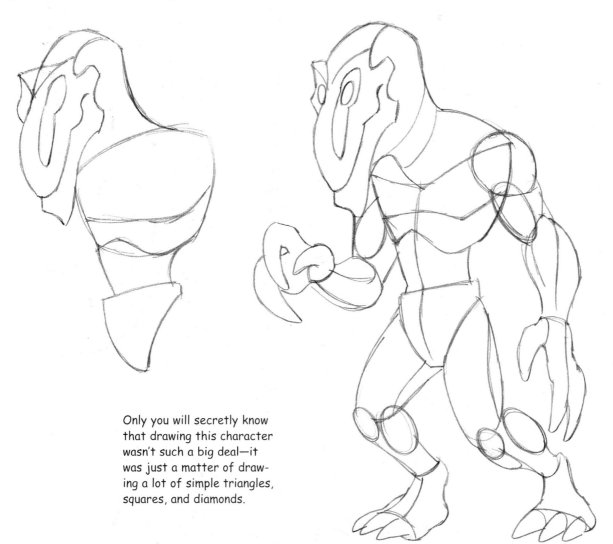

Only you will secretly know that drawing this character wasn't such a big deal—it was just a matter of drawing a lot of simple triangles, squares, and diamonds.

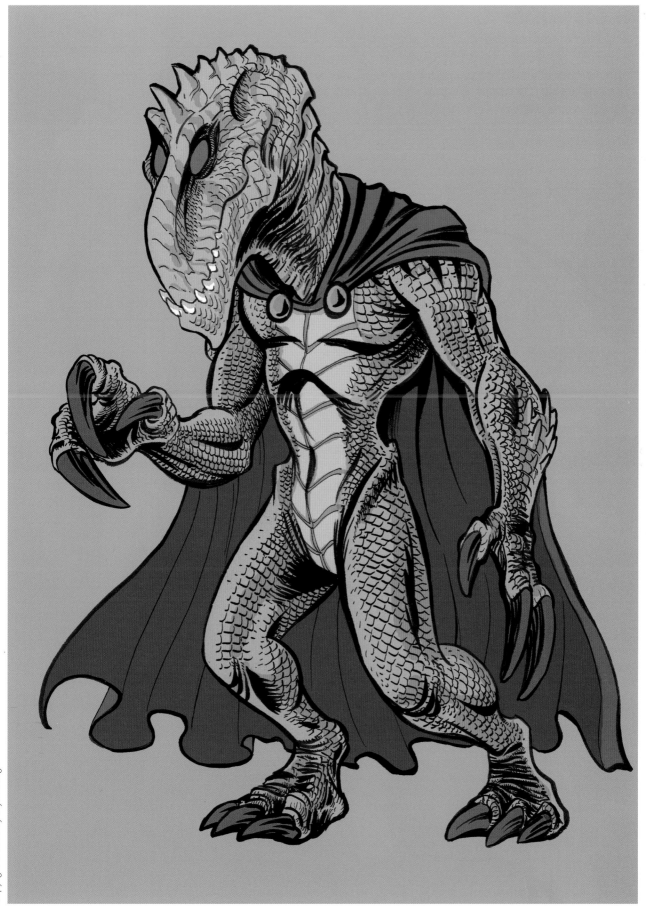

Jupiter Gas Whale

Floating within the cloudy atmosphere of the gas planet Jupiter is the giant Gas Whale, swallowing whatever hopeless, helpless life forms may cross its path. Weird as it might look, this is not a terribly difficult creature to draw. It's basically a series of connected circles. Its flippers are slightly curved diamond shapes—no big challenge. The hardest part is its mouth, which consists of an open maw surrounded by thick feelers for clutching prey. Even the feelers, when viewed as basic shapes, are only long, stretched-out ovals and rounded rectangles.

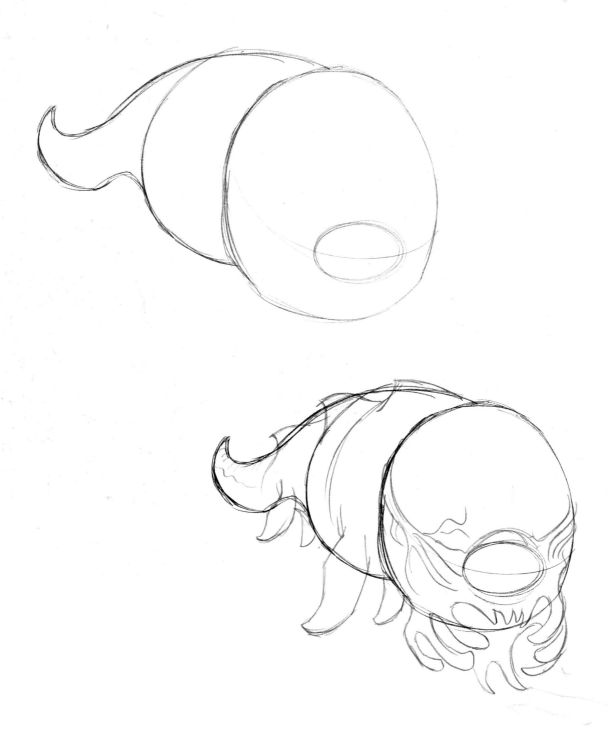

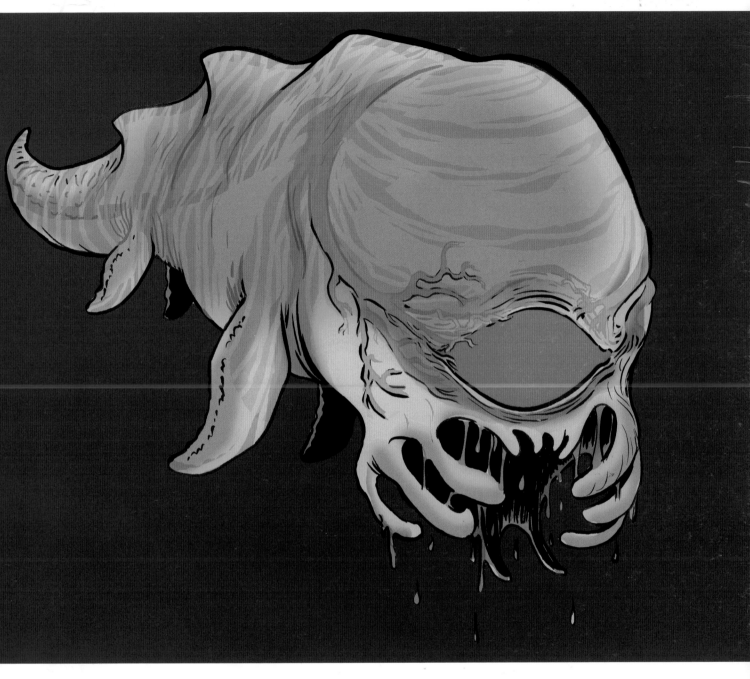

By viewing the different parts of any creature's body as a series of simple shapes, you can figure out how to draw even the strangest anatomical forms.

Martian Warlord

This cruel, warmongering leader of the military forces on Mars looks for excuses to start wars with other planets in order to conquer and amass them into the fast-spreading Martian empire. In many ways, this guy might be the most difficult character to draw in this book. But don't worry; it can be done! Just pay close attention to detail and do not rush. The first step requires the same old tried-and-true approach of laying out the basic figure with simple lines and forms. The tricky part is the specific anatomical shapes, which are different from those of humans. Note the careful construction of lines that is needed to create his skull-like face and enormous bug eyes, as well as his horns, exposed brains, and long, tentacle-like hair. There are also many overlapping limbs as well as armor on his body.

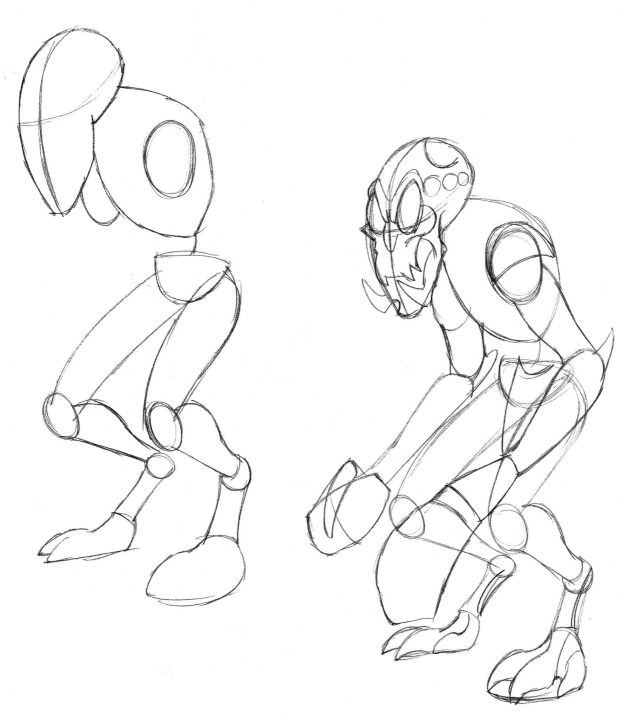

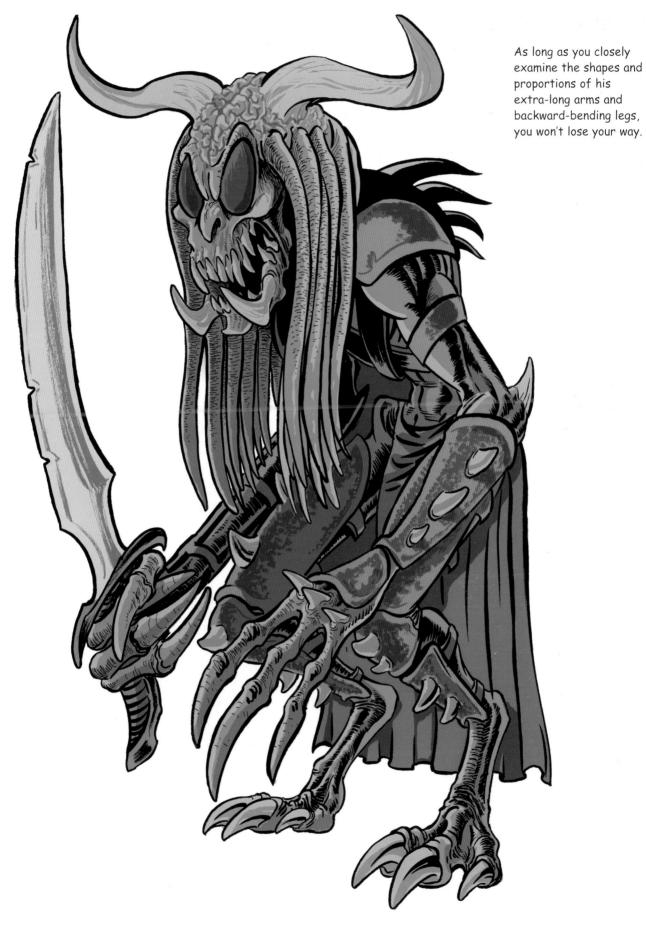

As long as you closely examine the shapes and proportions of his extra-long arms and backward-bending legs, you won't lose your way.

Alien Nightmare

Every bit as dangerous as it is scary, the Alien Nightmare is a horrible monster that is found lurking in the dark corners of several planets. It can move incredibly fast and will eat almost any living thing it can catch, but its favorite food is human flesh. From the neck down, this creature is pretty straightforward. The head, with all the crazy, overlapping tentacles, is what you may find challenging. But it is nothing to be afraid of. The tentacles are just long, slender shapes. Draw them one at a time, and you'll find them easy to work with. Furthermore, don't feel like you have to arrange them exactly like the example here.

Make your Alien Nightmare's tentacles waver and squirm in a completely different direction if you like. Note that his hands also sport tentacle fingers. Imagine those things grabbing you!

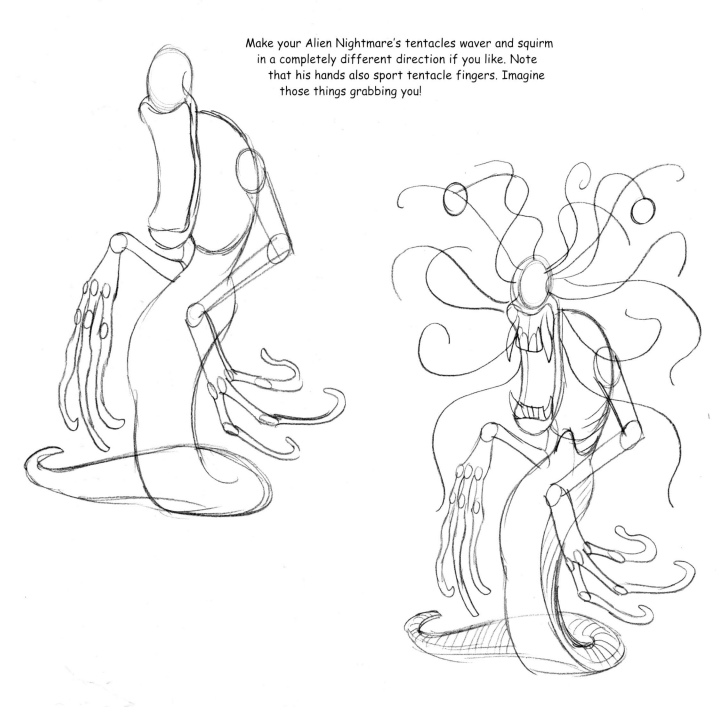

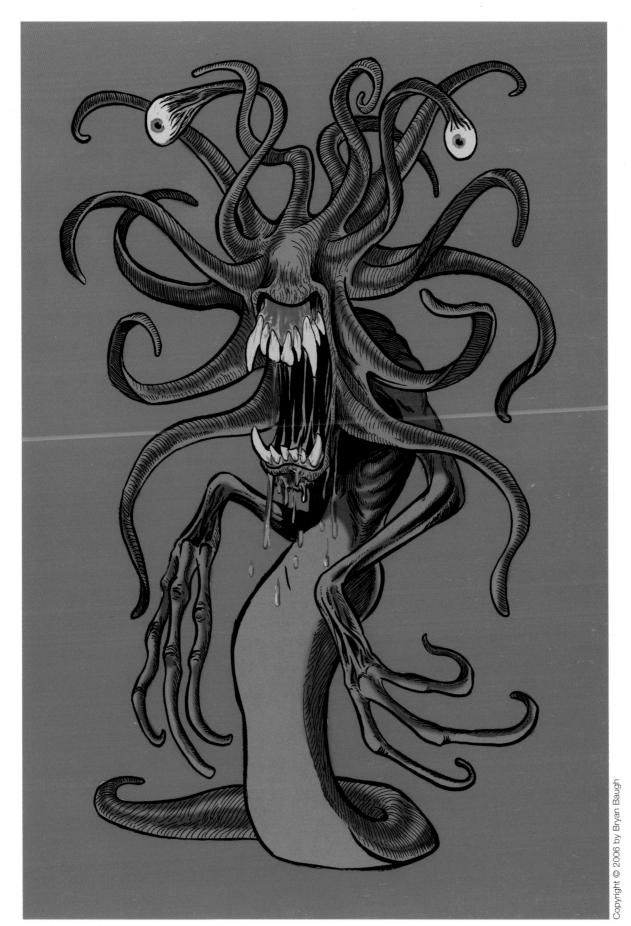

Space Gorilla

Believe it or not, there are races of intelligent apes living throughout the galaxy, whose physical appearance closely resembles that of gorillas on Earth. They have their own cities, spaceships, and desire to explore and learn about other worlds, just as we do.

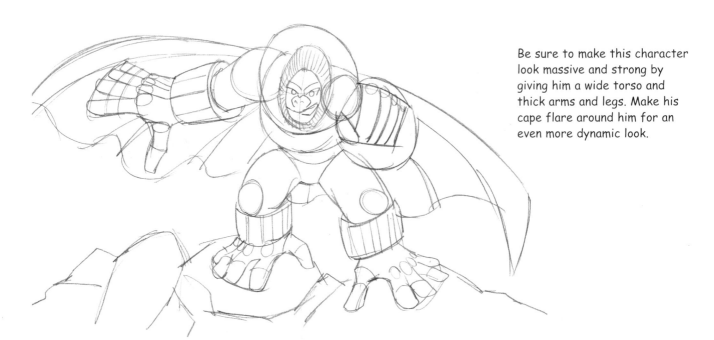

Be sure to make this character look massive and strong by giving him a wide torso and thick arms and legs. Make his cape flare around him for an even more dynamic look.

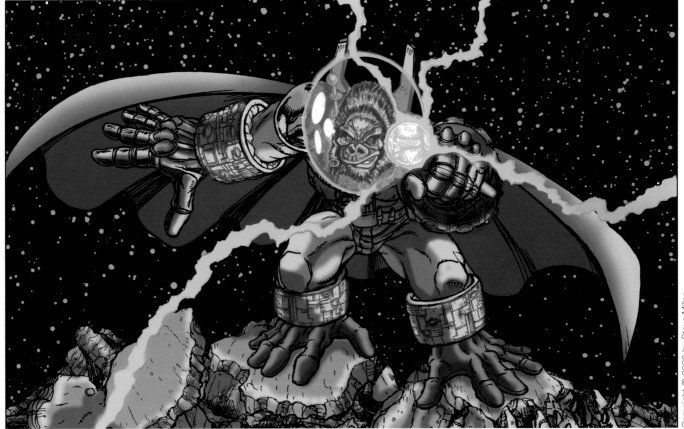

Uranian Brain Slug

Found on the planet Uranus, Brain Slugs are a hideous race of intelligent, yet disgusting and purely evil mollusks that thrive on eating the brains of other life forms. Pay close attention to how the lines and shapes are assembled.

There is no human anatomy whatsoever that you can rely on, as all of this creature's features are strange, imaginary forms. The important thing is to have fun and make this guy as creepy and disgusting as possible.

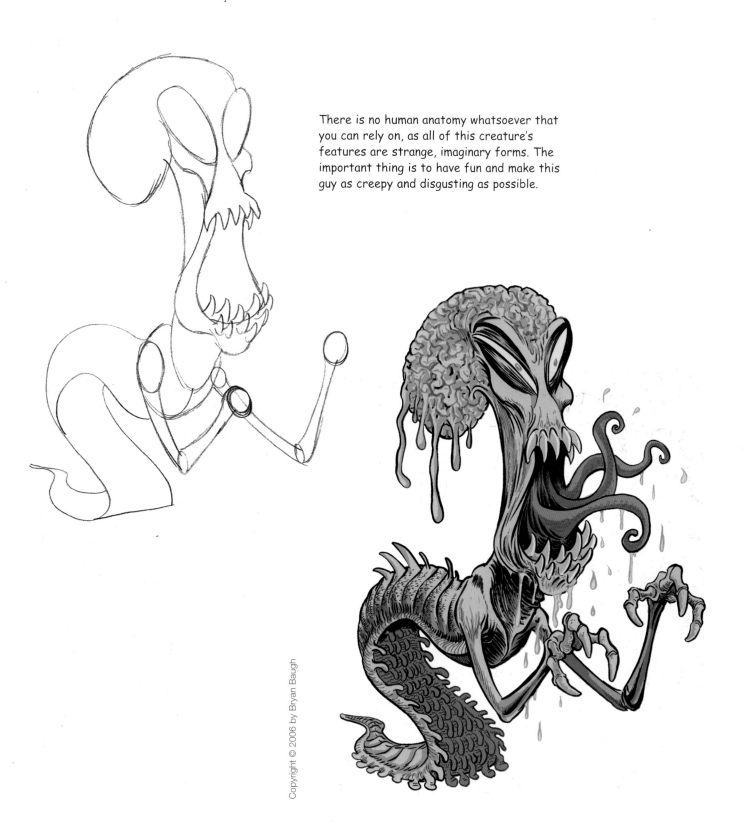

Space Bat

These winged nightmares are capable of swooping down into the atmospheres of planets and establishing themselves on terrestrial surfaces. To draw a character like this, you have to look past the overall image and figure out the simple shapes that make up its basic construction.

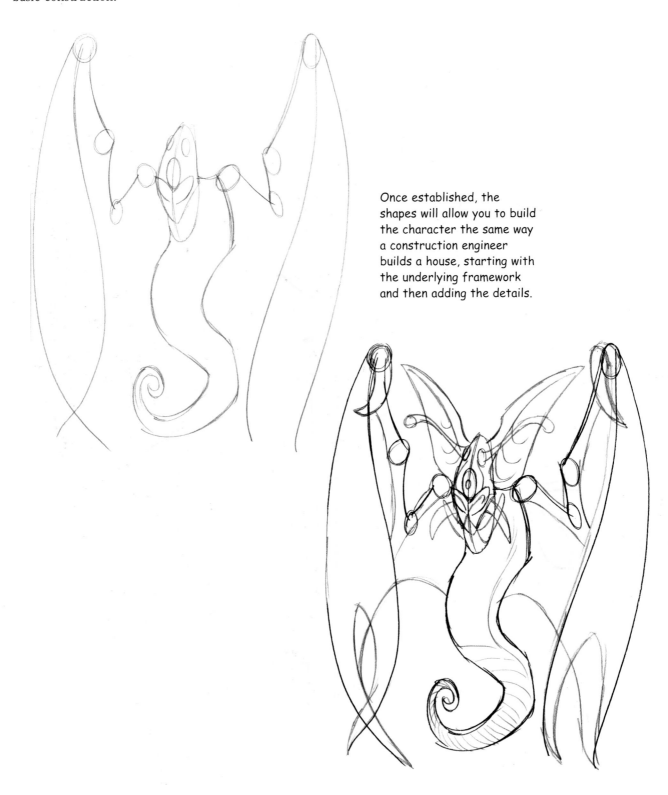

Once established, the shapes will allow you to build the character the same way a construction engineer builds a house, starting with the underlying framework and then adding the details.

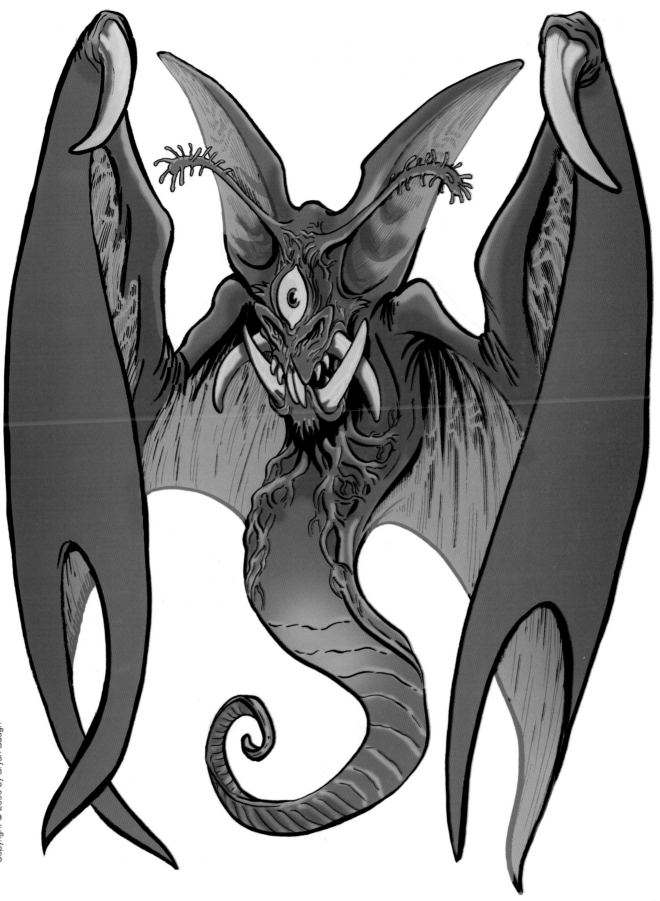

Evil Space Queen

The Evil Space Queen is not a nice lady, and she is known to conspire with the Evil Space Tyrant (*see* page 60) to gradually conquer every known planet in the universe. In this example, you've got to do more than just draw a pretty woman. You have to give the impression that this woman is pure evil, which is achieved in the details. Notice her arched eyebrows, narrow eyes, pointed ears, and fangs protruding from the corners of her mouth.

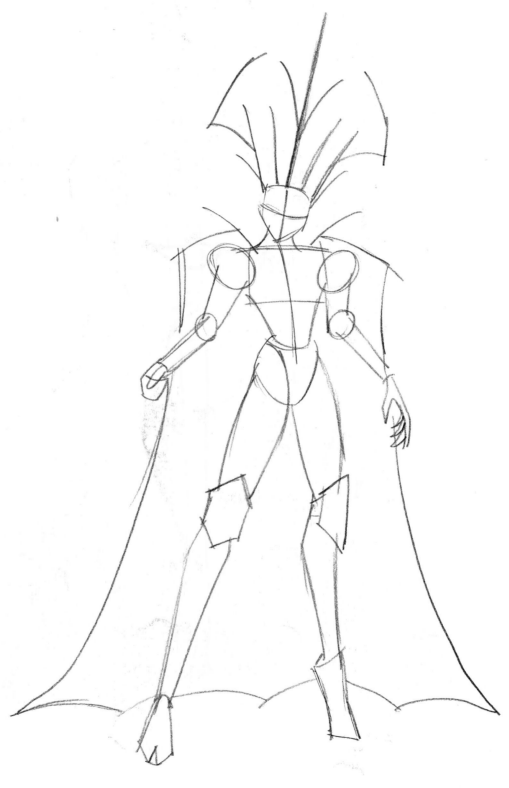

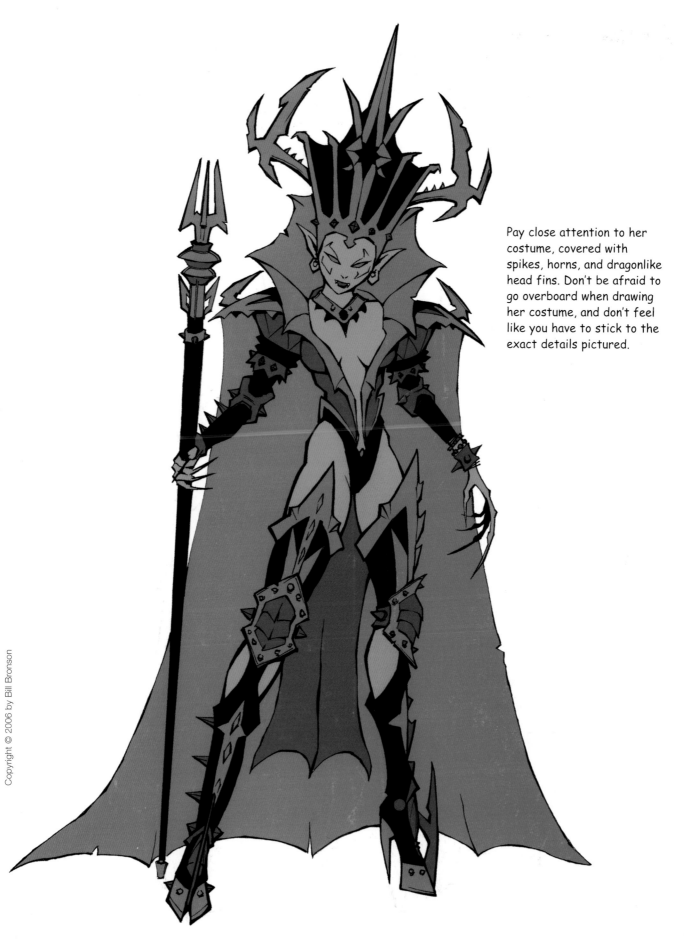

Pay close attention to her costume, covered with spikes, horns, and dragonlike head fins. Don't be afraid to go overboard when drawing her costume, and don't feel like you have to stick to the exact details pictured.

Neptune Aqua Guard

The planet Neptune has many underwater cities that are populated with these ugly, fishlike beings. They are very resistant to outsiders, and the guards can be especially nasty when driving away unwanted visitors. However, you need not be intimidated by drawing him. Once you look past his fishy appearance and examine the basic shapes, you will discover that this character is nothing more than a slouching human figure.

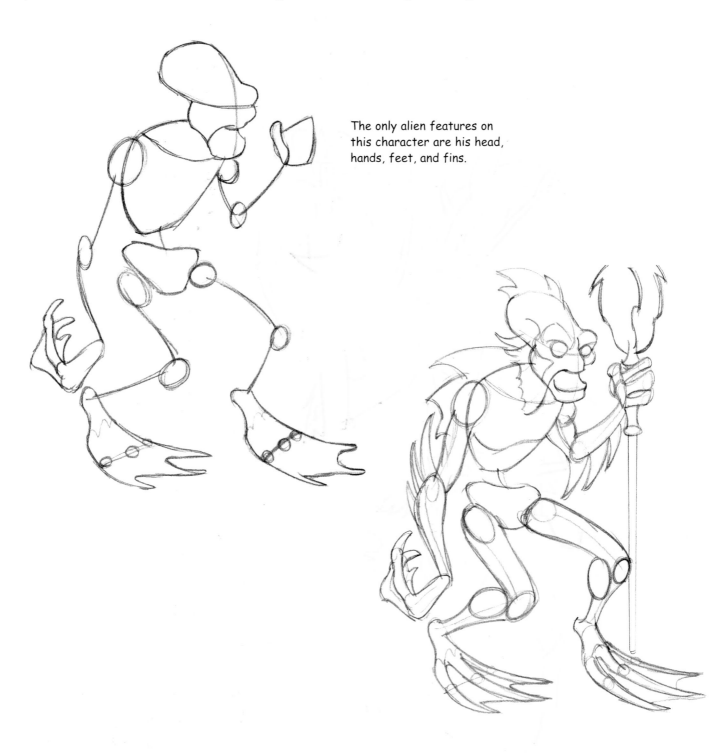

The only alien features on this character are his head, hands, feet, and fins.

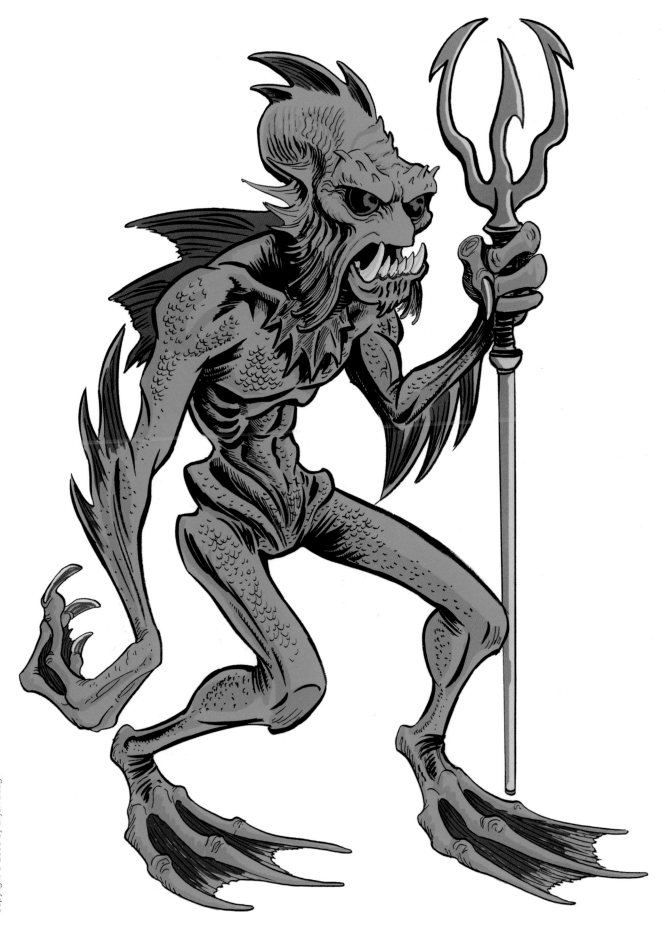

Lizard Man

Lizard Men come from many different planets and are common all over the galaxy. Despite their frightening appearance, they are known to be highly intelligent and very accepting of humans, and tend to attack only evil aliens. When drawing this character, pay close attention to its body proportions. Notice that in his basic stick-figure form, he is not structured like a human being at all. His arms are significantly longer than his legs; his neck is long and curving; and his hands and feet are not human. Of course, it would be easier to just draw a typical human body and decorate it with lizard features, but that would just look like a person wearing a lizard costume. This character needs to look and feel like an animal. Once you get his animalistic body proportions correct, everything else should flow smoothly.

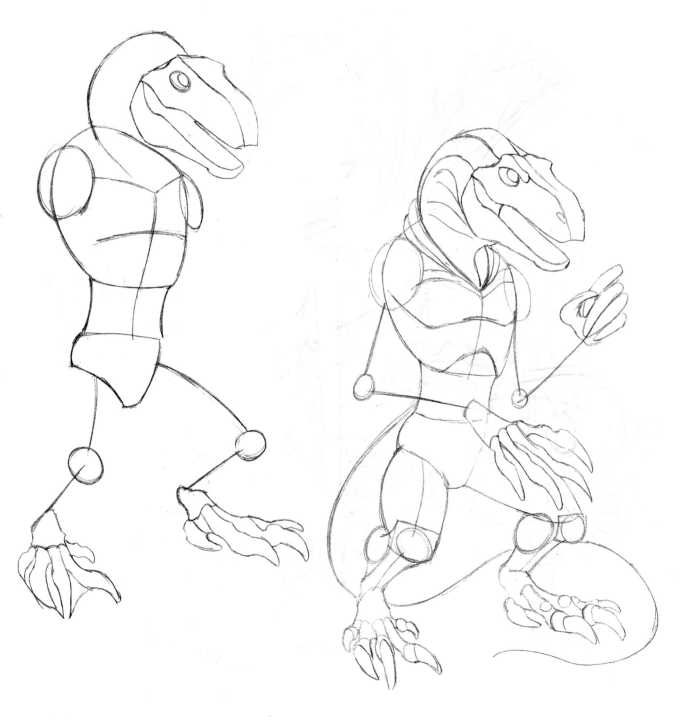

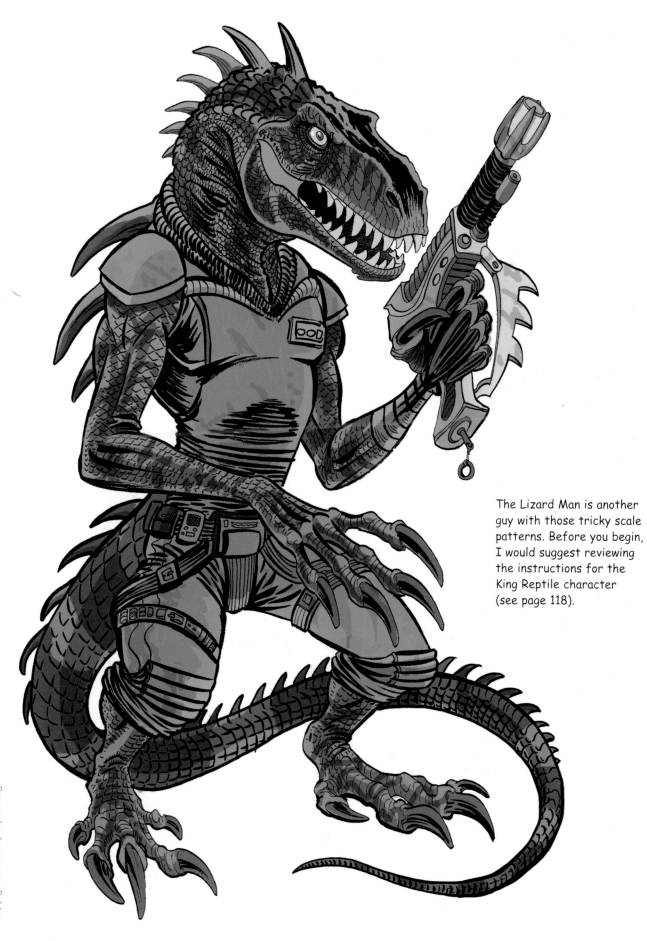

The Lizard Man is another guy with those tricky scale patterns. Before you begin, I would suggest reviewing the instructions for the King Reptile character (see page 118).

Saturn Quadian

These four-legged crustaceans are the dominant, intelligent race on the planet Saturn. They are highly aggressive and prone to blasting unwary space explorers first and asking questions later. The Saturn Quadian is another tricky character to draw due to the complexity of the arms and legs. Well, take heart: If you can draw one of those arms and one of those legs, you can draw all four of them. Afterward, it is simply a matter of making sure they are correctly attached to the body without any overlapping.

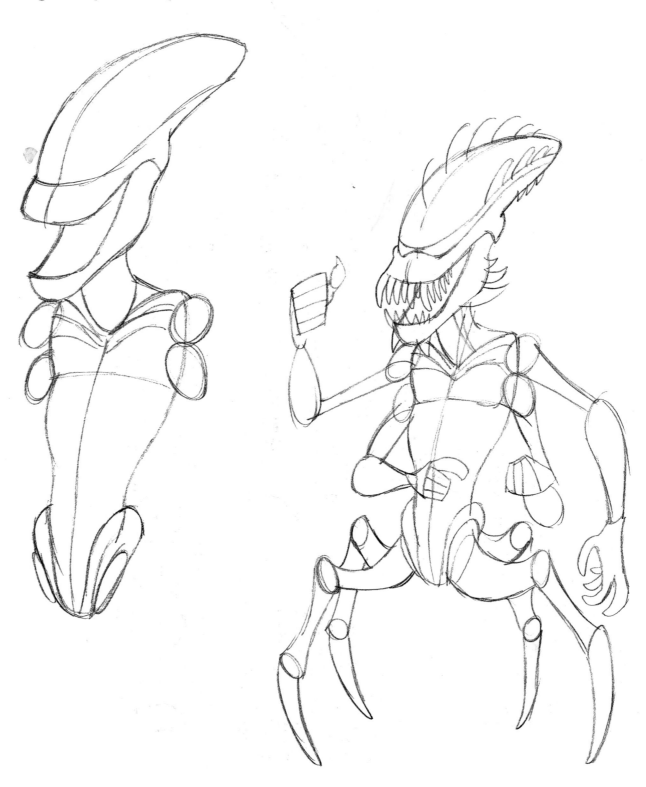

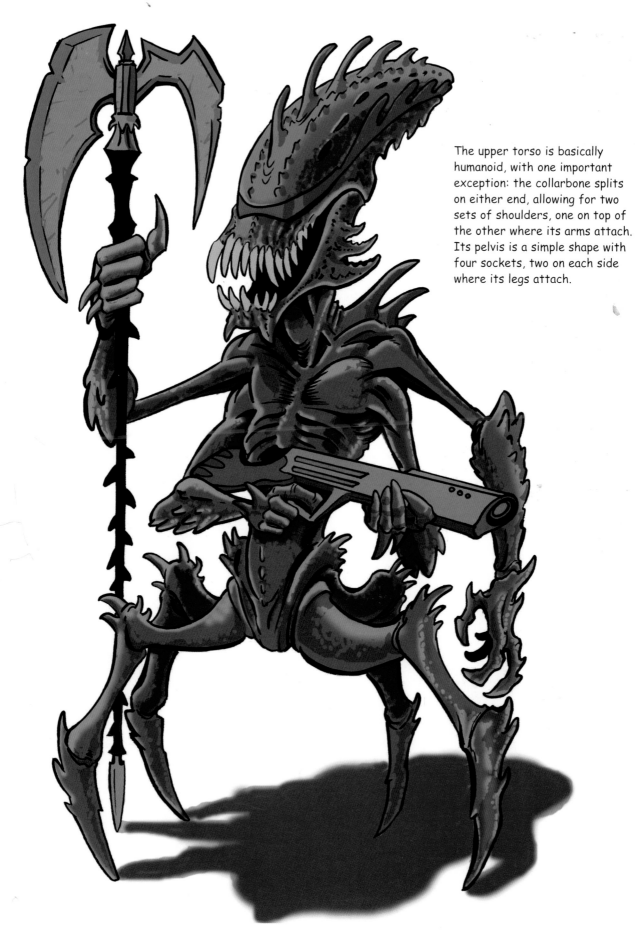

The upper torso is basically humanoid, with one important exception: the collarbone splits on either end, allowing for two sets of shoulders, one on top of the other where its arms attach. Its pelvis is a simple shape with four sockets, two on each side where its legs attach.

Space Monkey

Sent along on interstellar missions as a pet to keep astronauts company, the Space Monkey is an intelligent and loyal companion for those working in the dark, lonely depths of space.

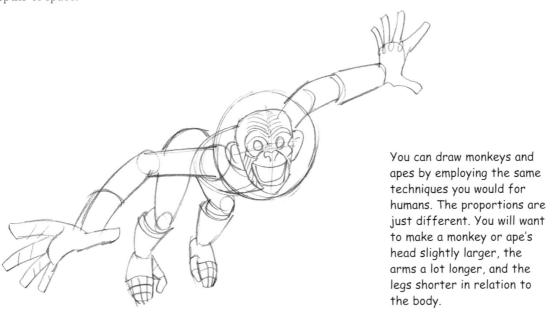

You can draw monkeys and apes by employing the same techniques you would for humans. The proportions are just different. You will want to make a monkey or ape's head slightly larger, the arms a lot longer, and the legs shorter in relation to the body.

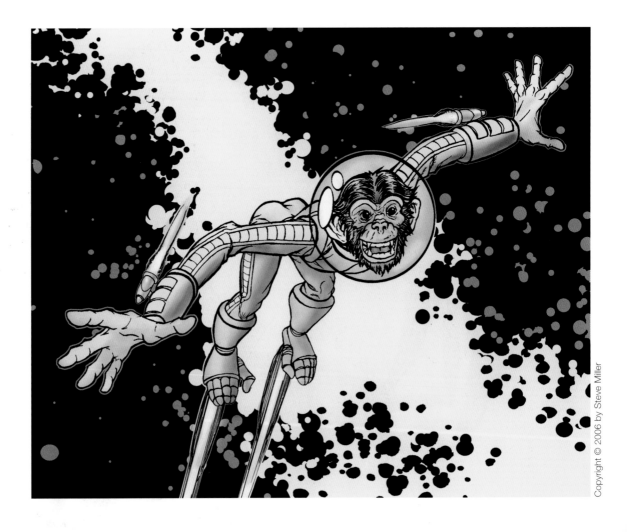

Gray Alien

One of the most common forms of intelligent alien life, these spooky beings travel all over the galaxy, exploring different planets. They are cold-hearted scientists, with little concern for the well-being of the life forms they capture for study and experimentation.

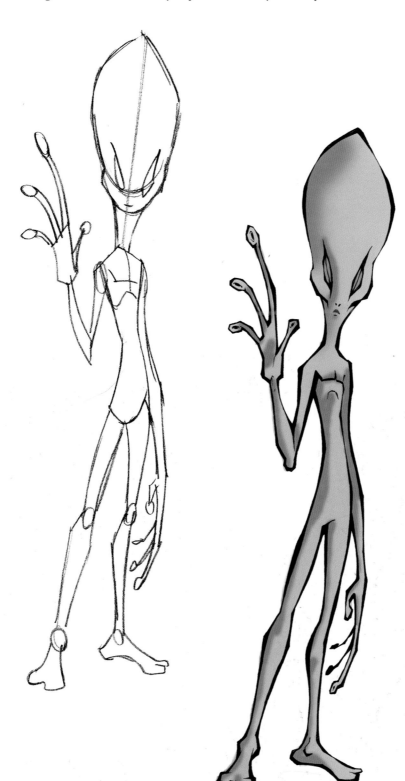

This is not a terribly difficult figure to draw, as long as you don't let it become too humanoid. Keep its head large and its body and arms as long and thin as possible. Its legs are quite skinny, although somewhat shorter than the arms. It's almost a stick figure even in the finished drawing!

Space Shark

An intergalactic eating machine, the Space Shark swims through the cosmos, hungry for space ships, astronauts, and mineral-rich debris to consume in its gaping maw.

If this monster looks very otherworldly to you, don't be fooled. All I did was to draw an ordinary shark with extra-huge eyes, strange body textures, and added tentacles.

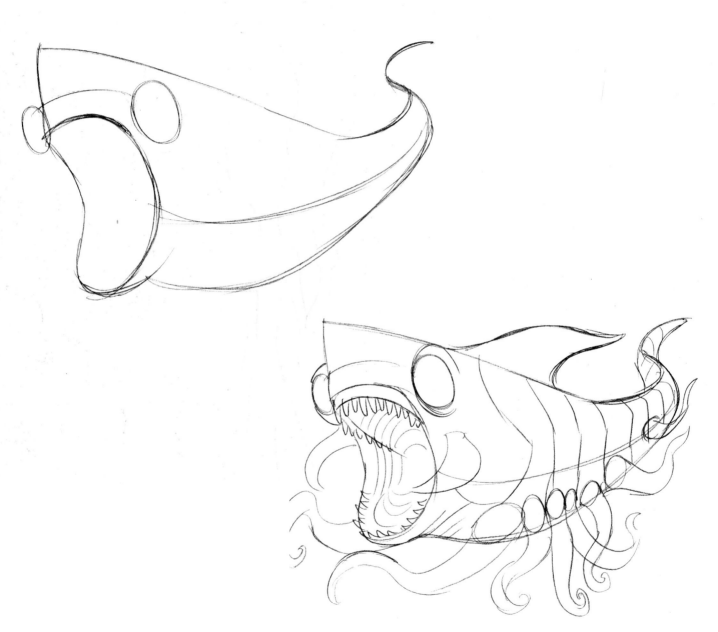

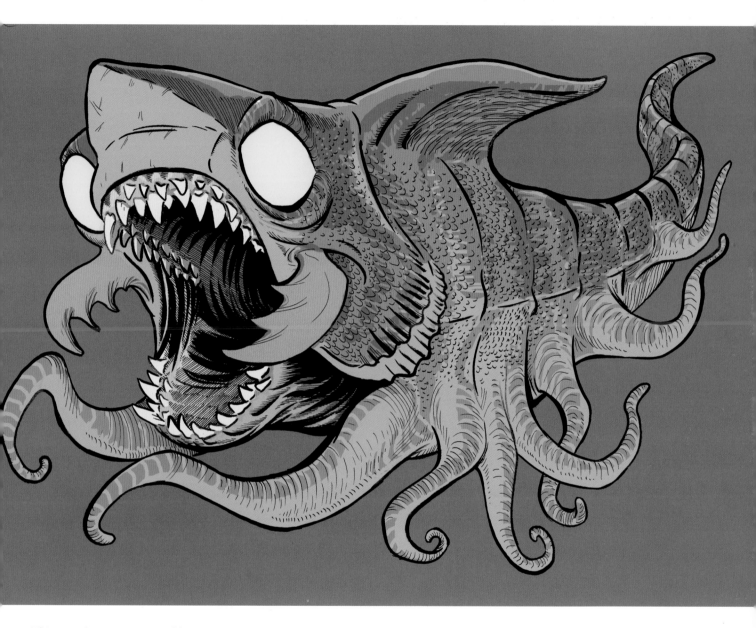

This is a demonstration of how easily you can create weird alien creatures by simply drawing normal Earth animals and adding strange features to them.

Space Elf

Dedicated protectors of nature, Space Elves have spread throughout the galaxy and made their homes on several different planets in their efforts to defend various alien environments from galactic colonization and industrialization.

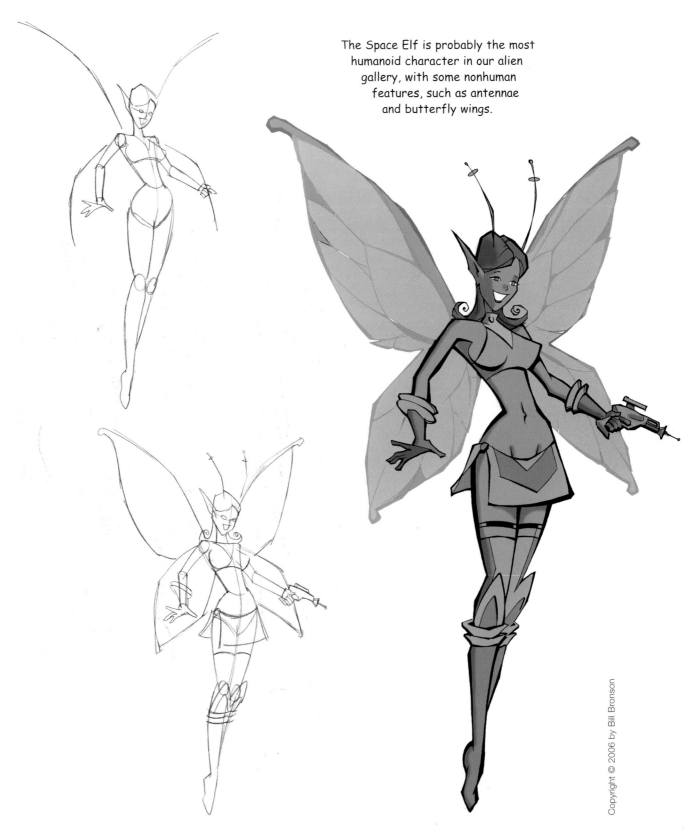

The Space Elf is probably the most humanoid character in our alien gallery, with some nonhuman features, such as antennae and butterfly wings.

Pluto Snow Ape

Being the planet farthest from the sun, Pluto receives little heat and remains a frozen world where creatures like the Snow Ape thrive. With powerful strength, sharp teeth and claws, and thick coats of fur that allow them to sustain extremely low temperatures, Snow Apes are well equipped to hunt for food, which can be anything from a planet's inhabitants to unlucky human explorers.

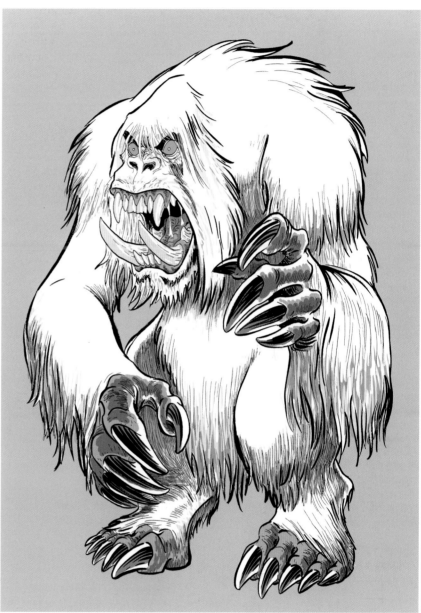

Don't let the fur texture scare you from trying to draw these creatures; it consists simply of long, scraggly lines. When you break the Snow Ape down to its most basic form, you'll see it's really nothing more than a bunch of circles and ovals piled together. Everything else is decoration that can be added at the end.

INDEX